CATHERINE LEE
THE ALPHABET SERIES
AND OTHER WORKS

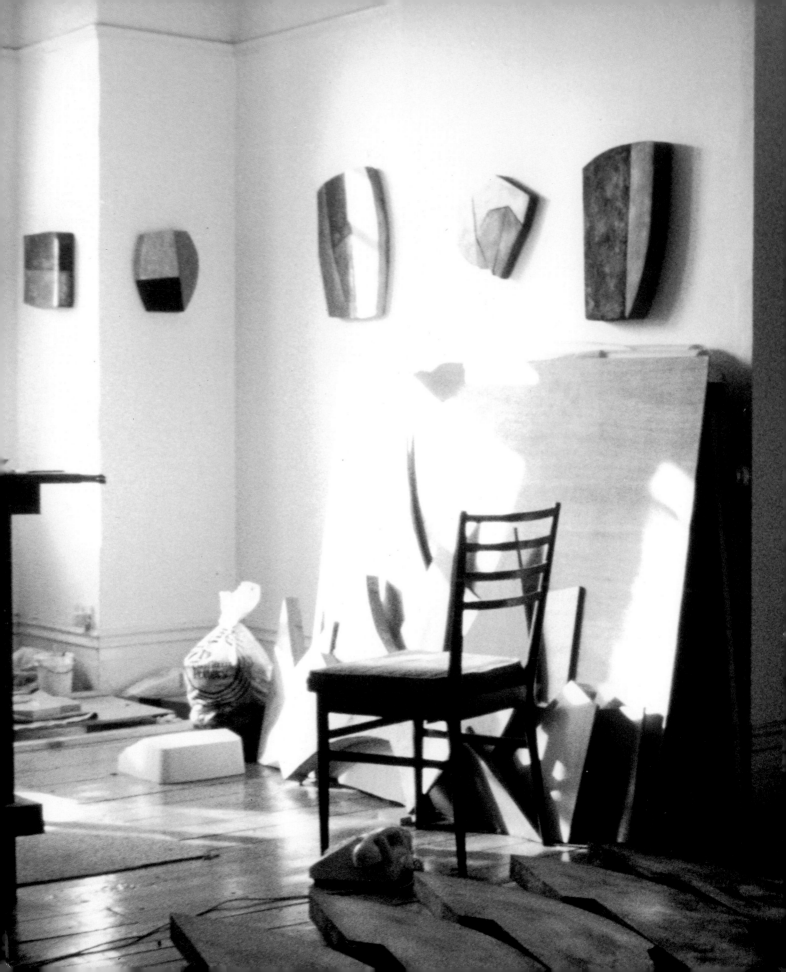

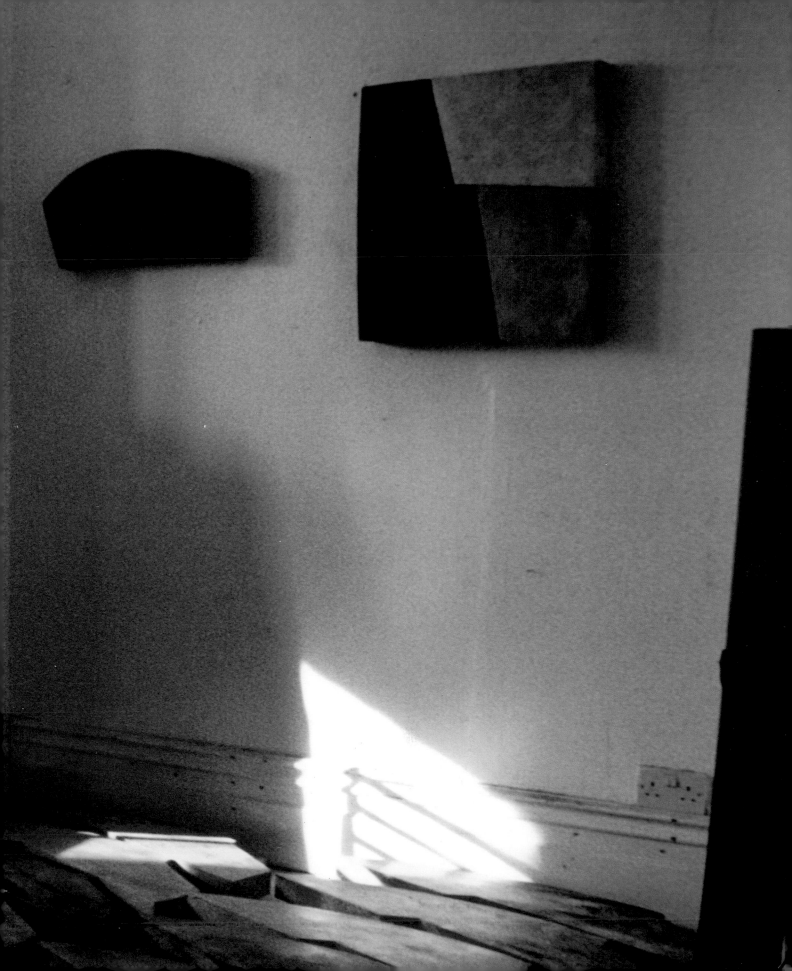

APRIL/MAY, 1996
ArtPace, A Foundation for Contemporary Art, San Antonio, Texas

NOVEMBER/DECEMBER, 1997
Sonoma State University, Rohnert Park, California

MARCH/APRIL, 1998
Bemis Art Center, Omaha, Nebraska

FEBRUARY/MARCH, 1999
San Diego State University, San Diego, California

SEPTEMBER/OCTOBER, 1999
Lafayette College, Easton, Pennsylvania

JANUARY/FEBRUARY, 2000
Lyman Allyn Art Museum, New London, Connecticut

UNIVERSITY OF WASHINGTON PRESS

Library of Congress Cataloging-in-Publication Data
Lee Catherine, 1950 -
Catherine Lee, The Alphabet Series and Other Works/Carter Ratcliff/Faye Hirsch.
p. cm.
Includes bibliographical references.
ISBN 0-9659746-0-x (paper)
1. Lee, Catherine, 1950 -
Exhibitions. I. Title
NE 1997

CONTENTS

CARTER RATCLIFF:
THE ART OF CATHERINE LEE

Catherine Lee cast *Xclacadznot* from bronze in 1995 (fig. 1). Bronze is like marble; it signifies sculpture and the long, exalted history of the medium. Yet *Xclacadznot* is not a sculpture, or not exactly that. Lee made it to hang on the wall. The work is flat, its surface is divided into segments, each division has its own color. *Xclacadznot* looks very much like a painting. Moreover, Lee applied its patinas with a brush. Yet this object has none of the weightless, levitating quality that a canvas displays the moment you hang it properly. Only fifteen inches high, it is a heavy object — you can see in a glance the metallic density of it. So *Xclacadznot* is not a painting, or not exactly that. But if it is neither a painting nor a sculpture, what is it?

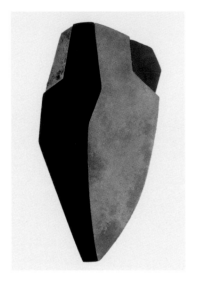

1. Xclacadznot, 1995
Cast bronze. 14.5 x 7.5 x 1 inches

Think of a movie that is neither a film noir nor a romantic comedy and yet borrows devices from those genres, and from others too. All that we have learned about the medium and its genres would be pertinent as we watched this movie; but none of that familiar knowledge would be quite sufficient. For the movie I've asked you to imagine uses the genres in ways that put it beyond their reach. Lee's recent work does something similar. Though it brings to mind painting, sculpture, and possibly ceramics, a piece like *Xclacadznot* is enclosed by no medium. As we approach the object, we don't know precisely in which direction we are being drawn. Yet we don't feel lost.

Xclacadznot, *Dun Liath* (1991), *Na Hearadh* (1993) — works like these free us to see line as line, color as color. The eye luxuriates in the texture of *Xclacadznot's* largest segment, for nothing mitigates the sheerly visual pleasure offered by this lush, grayish surface. And when the attention shifts to another segment of the piece, it is obeying no formal dictates, accepting no structural logic, only seeking further pleasures — whether in the dark region to the right of the gray or in the luminously earthen colors toward the top of *Xclacadznot*. Lee's art invites the eye be self-reliant, to devise its own itinerary. And its own rules.

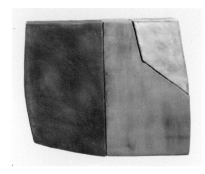

2. Verse, 1989
Encaustic on wood. 9.5 x 11 x 2 inches
Karsten and Claudia Greve, Köln, Germany

So far, we've been seeing her works as abstractions. Yet nothing prevents us from seeing in *Xclacadznot* an allusion to an ancient form, the clay vessel called an amphora. We can even take the sudden shift from light to dark as a shadow modeling the amphora's rounded volume. The line running the length of *Dun Liath* might be seen as a geological fault, and you could read the four parts of *Aleutian Islands* (1991) as the quadrants of a highly stylized mask, if you like. If not, you can find other allusions or none at all. Lee's works always stand ready to be counted as abstractions.

The quick way with these ambiguities is to say that Lee has positioned her bronze wall pieces at the border between the abstract and the representational. Or they live in abstraction's territory, but close enough to the border for crossings to be easy. But these accounts impute to Lee's works a coyness, a skittishness, which none of them ever displays. Whatever its size, each of her objects addresses us with the authority of her largest ones, which are more than human-scale. Pieces

3. Undertow, 1988
Oil on canvas. 79 x 86 inches

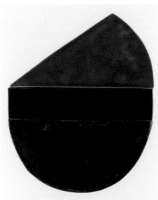

4. List, 1985
Glazed ceramic. 11 x 9 x 2 inches

like *Xclacadznot* and *Dun Liath* await us calmly, somewhere beyond considerations of abstraction and representation — considerations we bring to these works in the hope of enclosing them in familiar categories, or just to have something to say. But the works remain unenclosed.

Always, it seems, Lee has been impatient with conventions, especially those which define a painting as a flat, rectangular surface. In 1974 she cut a large color-field canvas into three-hundred squared-away objects. Drawing and painting on these small surfaces, she then stitched a layer of transparent plastic over each one and dispersed them by mail to friends. Though Lee continued to paint, her exasperation with the medium persisted. By the mid-1980s she had begun to build paintings from fragments, shaping her canvases and fitting them together in configurations that only sometimes preserved the

familiar, rectilinear format (fig. 3). As she made still more of these multi-paneled paintings, Lee transposed their structures to other mediums: encaustic on wood and glaze on ceramic (figs. 2, 4, 11). The outlines of these works grew increasingly eccentric, their internal divisions more lively. A painting is an object, literally speaking, yet it asks us to ignore its physicality—to see it as an image. Disenchanted by this pictorial irony, Lee was using wood and clay to tilt her imagery toward "objecthood," as it was dubbed in the polemics of the 1960s — not that she wanted to revive the old arguments. Rather, she had begun to confound the categories that supplied those arguments with their props.

Uninterested in making a kind of art, Lee intends her works simply as art — not as abstractions or representations, objects or images, paintings or sculptures. Lee acknowledges, of course, that all her pieces owe much to the history that defined the art-categories. She has no wish to reject that history, to erase the boundaries it drew. But she refuses to let her works be hemmed in by those boundaries, much as we refuse to be understood merely as members of one or another social category. We expect to be seen as individuals.

Lee has found her way to a zone prior to all the definitions, labels, and assumptions that give us our working, everyday sense of the aesthetic. It's impossible to know precisely how she found this freedom, though there may be a clue in a remark she recently made about the materials she prefers. They include "anything that has been in a liquid state — clay, concrete, fiberglass, all sorts of metal. I have difficulties with wood, because it begins as one thing and remains that one thing. Mutability is what interests me."[1] From shapeless fluidity she creates solid forms, and often she uses fire, to render a metal molten or to glaze a piece of clay. Transforming whatever she touches, Lee reminds me of an alchemist.

It might be said that every artist is something of an alchemist, at least metaphorically. I'd agree, especially if you were to point to such figures as James Lee Byers, Joseph Beuys, and Sigmar Polke in certain of his moods. Yet I believe that different metaphors make a better fit with other artists — and with Polke in his prevailing mood, which gives him the air not of an alchemist but of connoisseur who accumulates images and arranges them with ironic finesse. An artist like Sol LeWitt is more like a cartographer. Rather than rearrange the contents of the world, he maps its structure. So does Will Insley, though his maps are of a world he invented. Nonetheless, Insley's images are those of a surveyor, not of an artist stressing his resemblance to a god-like creator.

And there are art-world empiricists, who don't want to transform matter so much as display its properties — Robert Ryman, for example, or the early Brice

Marden. Artists like Donald Judd and Richard Serra are empiricists too, but far less solicitous of matter and its nuances. Subordinating materials to the will, they make monuments to willfulness itself. Their larger sculptures confront us with overbearing surrogates for the human presence. One tends to back away from these sculptures, seeking the point where it turns from an aggressive object into elegant image. Lee, too, makes large objects, yet hers draw us toward them with their tact.

Among the largest of her recent pieces is *Union Two* (1992) (fig. 5). Cast from bronze, it is just under eight feet in height. Flat, it stands flat against the wall. This detail of installation is not all that gives *Union Two* a vaguely human presence. It is composed of two bronze slabs, which fit together along a broken line. Running the length of the piece, this line suggests contrapposto: the twisting of the body — shoulders in one direction, hips in another, that animates so much ancient sculpture and Mannerist painting.

Successful contrapposto brings the counter-balanced masses of the human form to a believable stability — as, by implication, Lee's *Union Two* does. For all its zigs, zags, and careening outlines, this is a remarkably serene form. However elaborate the pose it insinuates, no muscles are being unduly strained — perhaps because muscles have nothing to do with it. We should always bear in

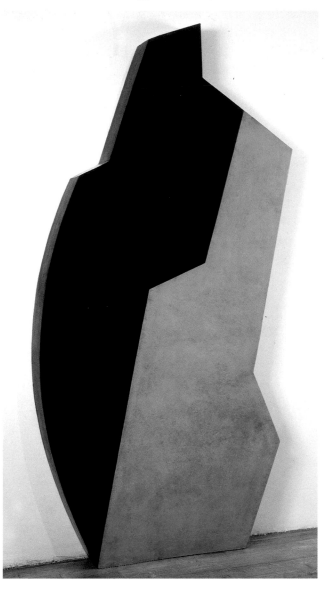

5. Union Two, 1992
Cast bronze. 81 x 40 x 5 inches

mind that Lee's objects make only the most tenuous allusions. Rather, we read allusions into them. If we didn't suffer such intense cravings for graspable meanings, an object like *Union Two* might stand before us innocent of references to anything. As it is, we pounce on the notion that the object has its feet solidly on the ground,

11

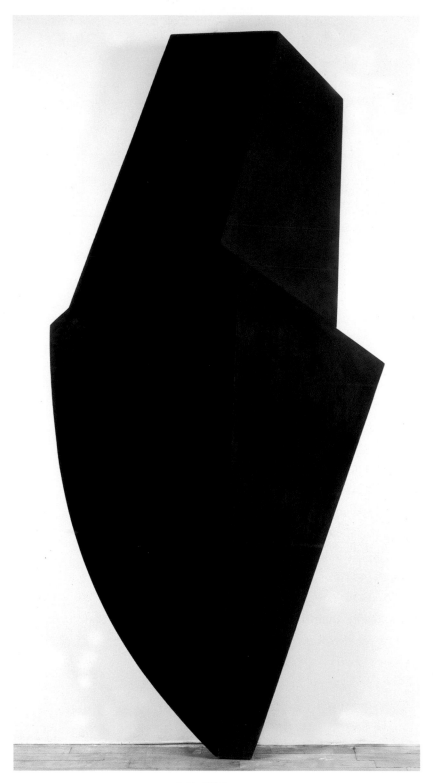

6. Red Wait, 1993
Cast bronze. 82 x 38 x 5 inches

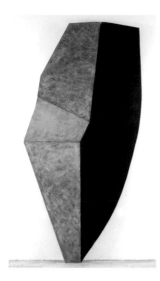

7. **Yielding Once, 1990**
Cast bronze. 95 x 45 x 2
inches

and *Union Two* assumes the look of a delicately hulking figure.

In fairness to our restless, grasping imaginations, I ought to note that Lee, too, reads a human presence into these large works. As she says, many are named for "things people could do." Somewhere near *Yielding Once* (1990) we find *Dancing Gold* (1989) (figs. 7, 8). The title *Red Wait* (1993) prepares us for quietude (fig. 6). Unlike *Union Two*, this work has a clear central axis: the division between its black segment and the brownish one to the right. Reaching toward the floor with the determination of a fence post, this dividing line anchors the piece to its site — locks it into its role, which is to wait. Or so one says, cued by the title. But the quietude of *Red Wait* is not absolute.

The angled upper edge of *Red Wait's* brown segment is like a tensed shoulder or a shelf of stone, a platform where the red segment finds only a rather precarious perch. From the body to geology is a short leap in the realm of Lee's allusions. The angular upper reaches of *Red Wait* suggest architecture too. Yet the size of pieces like these, and their willingness to share the floor with us, keeps drawing us to them as if they were somehow like us.

At a distance, the structures of the large pieces look decisive, as in a solidly engineered piece of equipment. Approaching, you see that a restrained sort of playfulness has shaped certain segments. Of course these works are monumental. And of course bronze is rigid, but as the edges of a work's component forms reach and curve and fit together, they take limberness from the artist's sense of freedom. Allusions to machinery or geology make way for hints of muscularity. Though the bronze surfaces of the large works never turn fleshly, their patinas sometimes have a warmth that feels almost organic.

The four elements of *Die Geiste* (1991) are forty-four inches high, a size which puts them roughly midway between the standing pieces and the works of the Alphabet series (fig. 9).

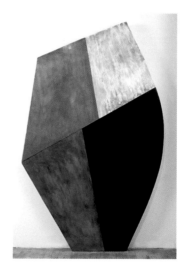

8. **Dancing Gold, 1989**
Cast bronze. 84 x 51 x 4 inches

Made of clay, Lee glazed three of them in shades of gray. The fourth is almost as pale as the white gallery wall where you'd expect to see it — a ghostly variant on the others, though that image might not come to mind without the help of the title. One meaning of "die geiste" is "the ghosts." "Geist" also means "spirit" and "mind."

Let these words drift into the vicinity of this piece and you might see its four

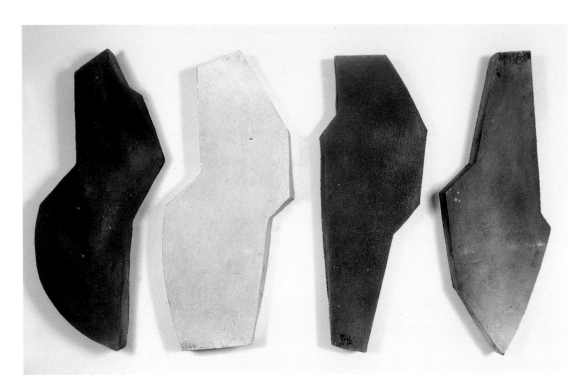

9. Die Geiste, 1991
Glazed ceramic. 44 x 78 x 5 inches

parts as somehow more ethereal than an obviously solid piece — *Xclacadznot*, for instance, or *Dun Liath*. It might seem that *Die Geiste* is looming up from imaginary depths or sinking into them, that its forms, as they float, shift as freely as unencumbered thoughts. The words "mind," "spirit," and "ghost" can inspire endless readings, and there's no harm in any of them so long as we remember that their opposites are equally legitimate. If the whitish element of *Die Geiste* is ghostly, ectoplasmic, it is also frankly physical.

Some of Lee's titles may be feints: cues which, if followed too closely, will throw us off balance. To compensate, we lunge in the opposite direction. Yes, the two parts of *Union Two* cleave together with the intimacy of neighboring geological strata, yet there's disunity here, also. Focus on the contrast between the two patinas, light against dark, and suddenly you see an extreme figure-ground effect. Ambiguity deepens as you try to decide if the pale bluish-green segment is the figure or the ground.

Lee says that she never intends a title "to be a key into the work. I try to keep it abstract." Often, she keeps it arbitrary too. The twenty-six forms of the Alphabet series are joined by no necessity except Lee's need for a system and her liking for readymade ones. Nor is there any compelling reason for each letter

of the alphabet to be expanded into a place name. These places mean something to the artist — she has visited each one — but she doesn't expect them to mean anything to us. Moreover, the form of a piece like *Youngstown* (1995) isn't in any way a representation of that place. There may be a temptation to see a charred hellishness in the black and gray surfaces of *Hades* (1992), but this title is another feint, I think. We might as well see the darkness of *Hades* as richly sensuous, for that is how similar tones look in works that lack names as loaded as this one.

Lee casts every Alphabet form four times, and of course she gives each casting a distinct patination. These colors, she says, are sometimes reminiscences of the places named in the title of a work. Sometimes they are not. But none of that ought to matter to us. Our interest is in what we can see in Lee's works, as they are now, and her inventions can be dramatic — see the Voices pieces of the early 1990s, which overwhelm the wall with sheer reiteration (figs. 12, 24).

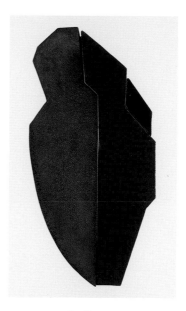

10. Austin 2, 1993
Cast iron and glazed ceramic
22.5 x 11 x 1.5 inches

Often, her inventiveness is subtle, as in the realignments that distinguish the "W" shape from the "X" shape in the Alphabet series. It's as if she were showing us the same form in a different posture. Of course the four versions of a single letter are the same form, a point that Lee's patination sometimes emphasizes. The play of colors in *Skye* (1993) and *Sleat* (1993) gives the look of close cousins, even siblings, to these "S" forms. Rethinking her colors for *San Marcos* (1993), Lee remade the form. You have to look closely to see that *Scarista* (1993) is at all related to *Skye* and *Sleat*, never mind structurally identical (figs. 13 - 16).

11. Shade, 1991
Glazed ceramic
67 x 22 x 5 inches

Lee's art implies a world, one that she creates by turning fluid chaos into stable order. I've said that she reminds me of an alchemist, and there is something astonishing about her command over the transforming powers of fire. Yet I don't want to insist too stubbornly on this metaphor, which is not a truth. Just a means of rousing the imagination, a metaphor will lead us astray if we let it.

To compare Lee to an alchemist is to make her interests seem much narrower than they are. Alchemy was driven by the single, obsessive desire to change base materials into precious ones. Lead was to become gold. When Lee

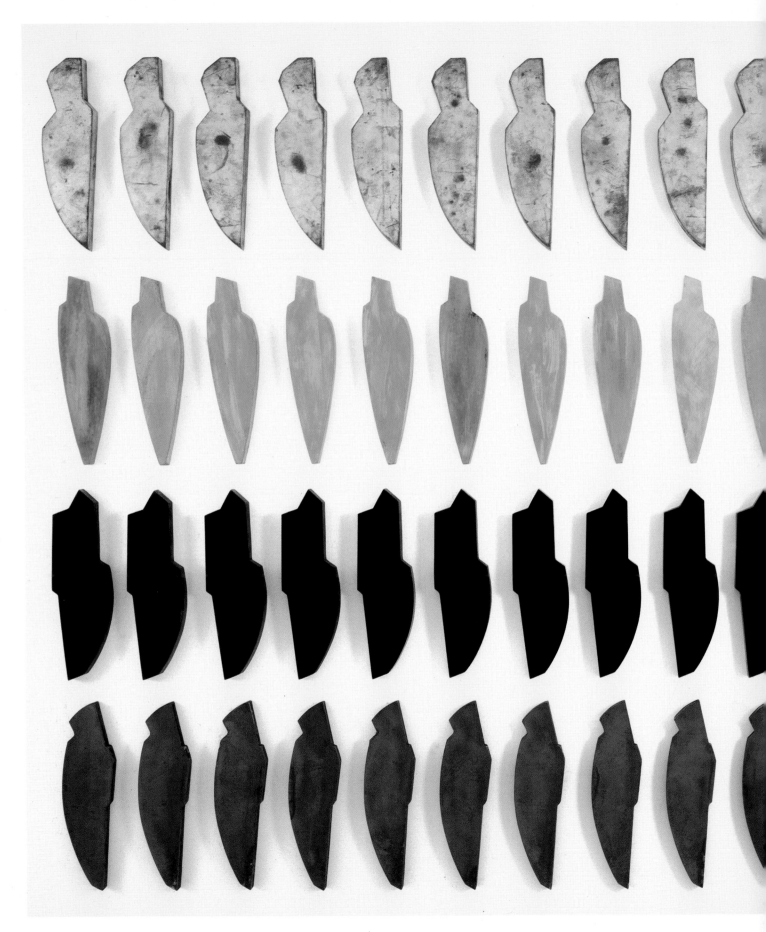

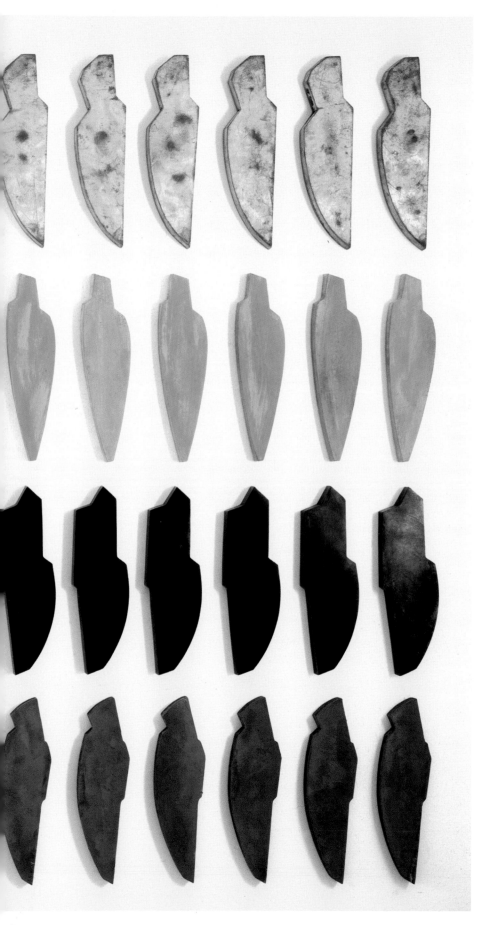

12. OTHER VOICES

1993
Cast lead, copper, bronze, iron
100 x 141 x 2 inches

casts lead, the result is a leaden object. The material's value has been enhanced, yes, but only in that incalculable way labeled aesthetic. Lee appears to be interested less in preciousness, literal or imaginary, than in the possibility of new forms, textures, and colors.

Her transformations are tireless, producing an abundance which suggests that abundance itself is of primary value — but only if it is embodied in works of art that have the weight, the presence, of the familiar world's more substantial things. Lee's is an art of securely self-possessed objects. Because she is not, like an alchemist, fixated on a single precious substance, it might be better to compare her to a cosmographer, one who speculates on the birth and evolution of the universe. No matter how highly evolved their forms may be, I detect in Lee's works a passion for primal materials, primal states of being. That's why it is so unsatisfactory to call her a painter, a sculptor, a ceramicist. She is a cosmographer whose speculations about matter employ matter itself.

No metaphorical role is simple. Though Marden lacks the alchemist's pretensions to occult knowledge, he can't help transforming the paint he examines with his "empirical" manner of applying paint. And, as willful as Serra may sometimes be, his early monuments are precarious enough to be seen as allegories of fallibility, of the vanity of the will. We could understand him as a moralist, of sorts. None of the monument makers are the detached, impersonal builders they often claim to be. A monument's attempt to transcend the merely individual always tells us something about the artist who yearns for that transcendence.

Nothing is more expressive than the denial of expressiveness, and nothing is more pointless than that denial. To have an artist's self is to be self-expressive. At any rate, that axiom has been persuasive since the very beginning of modern times. "Style is the image of character," said Edward Gibbon, toward the end of the 18th century. Near the beginning of the next, Samuel Taylor Coleridge argued that everything in Shakespeare's plays, from the smallest nuance of style to the grandest effect of structure, is a reflection not only of external nature but of the playwright's inward self — for Shakespeare is "nature humanized." [2]

Since then, much critical analysis has been a search for the artist in the art, on the assumption — never entirely incorrect — that any artifact as highly-wrought as an ambitious artwork is bound to bear revealing traces of its maker. This rule applies as inexorably to Robert Ryman as to Ernst Kirchner, the German Expressionist. The agitated brush work in Kirchner's pictures of the city's denizens expresses modern angst, let us say. Ryman's methodical laying on of paint is a sign of his patience, his attentiveness, and the quiet intensity of his eye and spirit.

Lee also shows us brushwork, and its expressive range is vast — from

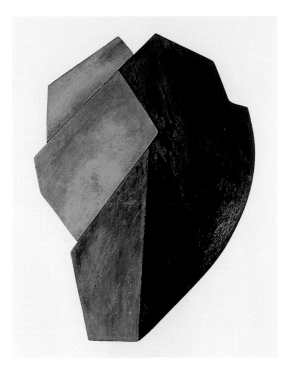

13. Sleat, 1993
Cast bronze. 11 x 7.5 x 2 inches

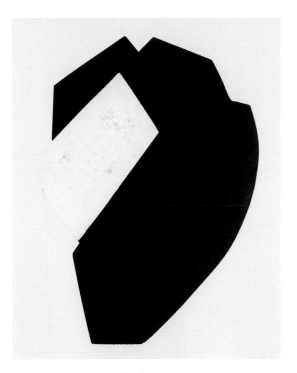

14. Scarista, 1993
Cast bronze. 11.5 x 8 x 2 inches

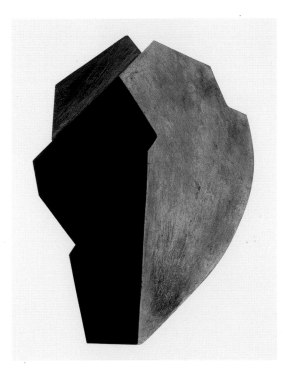

15. San Marcos, 1993
Cast bronze. 11 x 7.5 x 2 inches

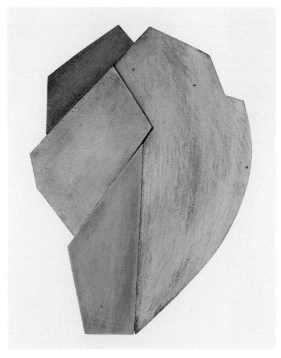

16. Skye, 1993
Cast bronze. 11 x 7.5 x 2 inches
Private collection, New York

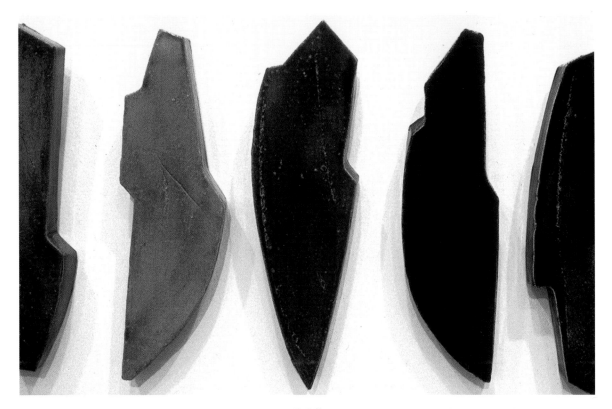

Detail

17. WISHES

1996
Raku ceramic. 12 x 148 x 1 inches

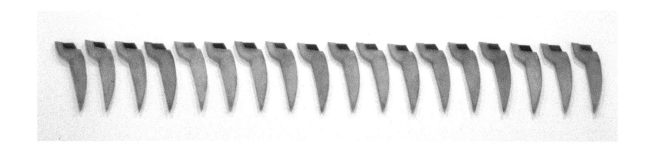

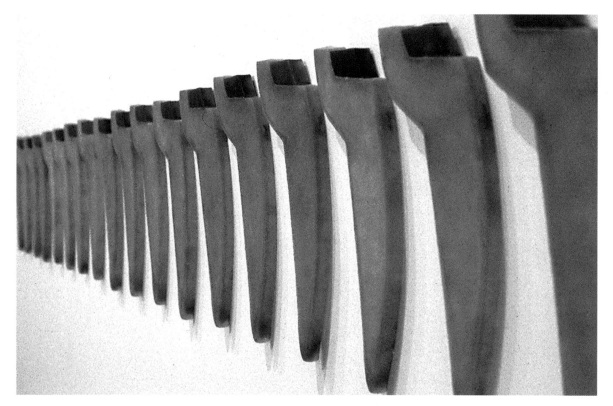

Detail

18. LIGHTENING
1996
Fiberglass. 15 x 114 x 1 inches

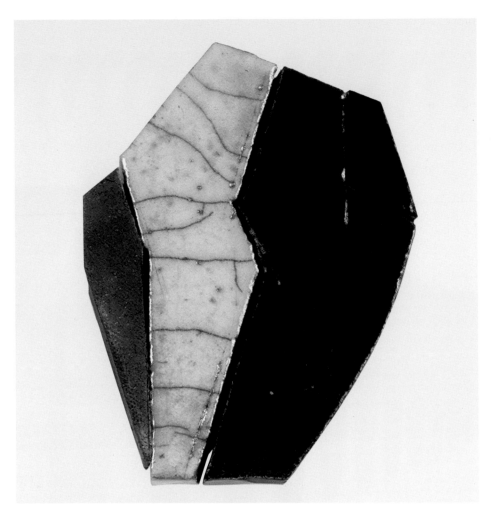

19. Treasure, 1995
Raku ceramic. 5 x 3.5 x 1 inches
Private collection, Munich

delicacy to violence. In interpreting these effects, we need to bear in mind that she doesn't paint the surfaces of her bronzes; she patinates them. Rather than lay a color over a surface, she draws it from the surface itself, by changing the metal chemically. Masked, with a blowtorch in one hand and a paint brush in the other, Lee applies an acid and the flame oxidizes the metal. She is "playing with fire," as she says, and despite her mastery of the process, its results are never entirely predictable. She has abdicated a painter's control over her colors.

The feathery luster of a particularly luminous patina may owe as much to the flame of Lee's torch as to her intention, which is not to say that she submits her art to the workings of sheer chance. If a patina turns out badly, she sands it down and tries again. We are to see the faintest detail of every work as fully intended. The point is that Lee lets her intentions blend with the physical

processes she employs. When a patina succeeds, it is a sign that her will has been at one with the fiery extremes of a chemical reaction, and that is in part why her bronzes have a primordial presence.

Lee's most violently unpredictable method is raku, a kind of glazing invented in ancient Japan. She learned the method from Steven Reynolds and Billy Ray Mangham, artists and colleagues from her native Texas. And Lee says she is still learning. "You can never completely control it," she says. "A raku firing is always an exercise in crisis management. More often than not, it plays havoc with the glaze. But the results can be amazing." Cracks run through the light segments of *Bracken*, a raku piece from 1996 (fig. 20). The effect is of stone abraded by weather and time, as in *Treasure* (1995) (fig. 19). Sometimes raku gives clay the density of iron or an almost jadelike light. Or a craquelure so fine that the eye takes it for shadow.

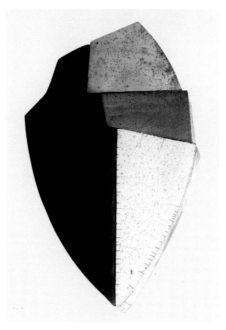

20. Bracken, 1996
Raku ceramic. 20 x 12 x 2 inches

The variety of her finished works — and the subtleties that differentiate them — suggest that her sensibility is as mutable as her materials. Fascinated by fire and risk, she is drawn to the drama of the kiln and the foundry. She is also a contemplative artist absorbed by the stillness of nuance. If I look at the Alphabet series in a sober mood, I'm reminded of a botanist's visual record of all the orchid varieties in a rain forest, or of a Darwinian's inventory of the beaks of finches in the Galapagos.

Because Lee makes the objects that compose her inventories, she is both a force of nature and a naturalist with a penchant for the elemental. Birds and flowers may be implied by some of her colors and a very few of her forms, yet she tends to avoid even oblique references to such things. Her allusions are to primordial objects, or to the idea — the feel — of the primordial. *Valentine* (1995), which is named after the artist's son, Parker Valentine, consists of ninety raku pieces, each fifteen inches high (fig. 21). Some might remind you of blades, others have a distant resemblance to Cycladic figures. Arranged in three rows of thirty, they occupy an entire wall.

Distributed across the three rows are nine forms, each repeated ten times.

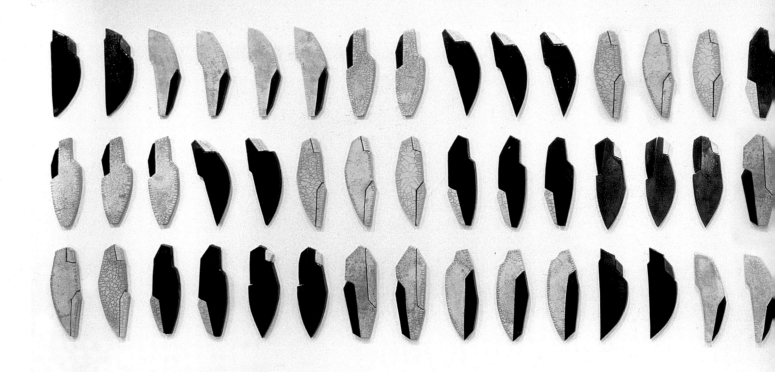

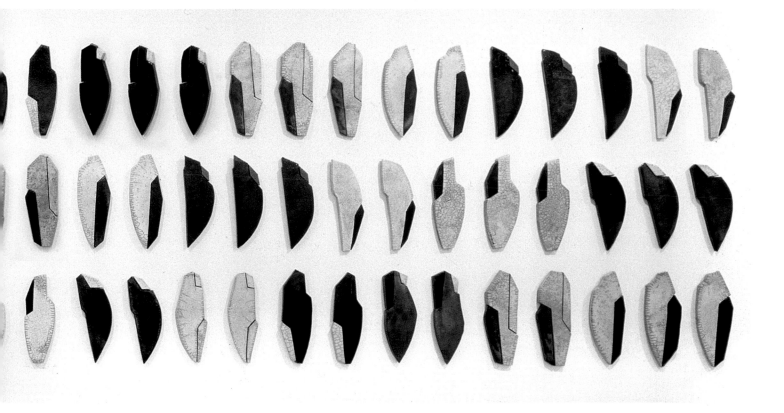

21. VALENTINE

1995
Raku ceramic. 54 x 236 x 1 inches

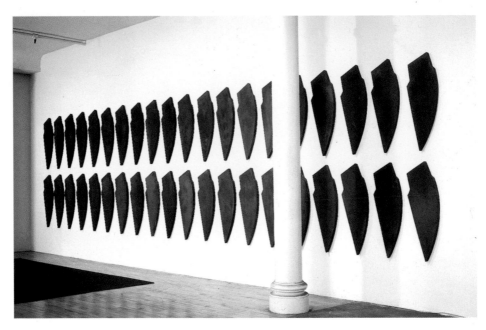

22. Doublecross, 1991.
Cast iron. 74 x 336 x 2 inches

This pattern emerges only after the eye disengages itself from immediacies of tone and texture. Each of the ninety units is rich with detail, and in subtle ways each is unique because Lee formed them all by hand. Step back, and you see not only the overall pattern of *Valentine* but the archaeological aura it shares with works like *Doublecross* (1991) and *Bronze Plummets* (1996) (figs. 22,23). The repeated forms of these serial pieces allude to such things as pottery shards and arrowheads, objects made by hand in a time when culture had not yet begun to extricate itself from nature. Lee doesn't evoke artifacts so much as the power of artifacts to symbolize the plenitude—the blend of the natural and the cultural — that generated ancient forms.

Despite our attempts to shape it, to render it intelligible, the ordinary world is opaque, resistant to our intentions and speculations. Lee is the cosmographer of a world that welcomes our speculative impulses, however minute or grand, for she brought this world into being with us in mind, and it awaits whatever energies of feeling and thought that we can bring to it.

[1] *Remarks by the artist are taken from conversations with the author that were held on May 15 and June 4, 1997.*

[2] *Gibbon's remark appears in his Memoirs (1796), ed. Henry Morely (London, 1891), p. 35. Coleridge's image of Shakespeare as "nature humanized" is from lecture notes written in 1808; see Coleridge's Writings on Shakespeare, ed. Terence Hawkes (New York, 1959), pp. 67-68.*

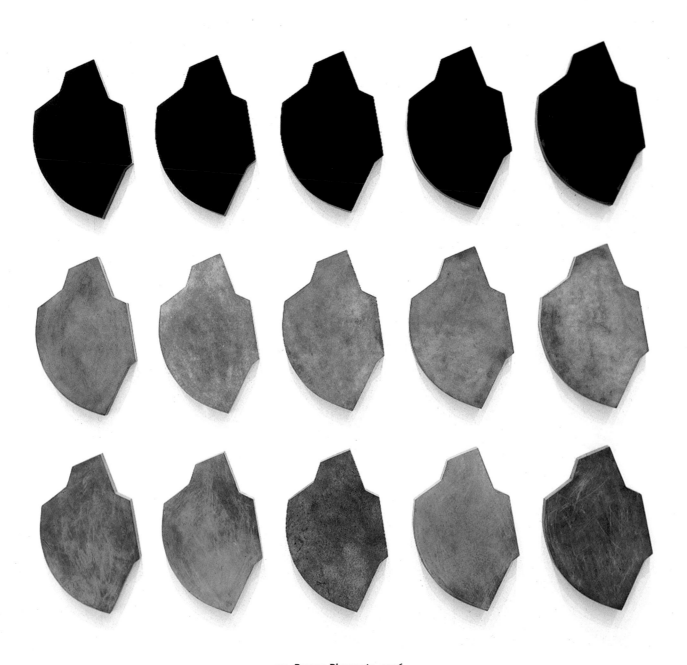

23. Bronze Plummets, 1996
Cast bronze. 89 x 102 x 2.5 inches

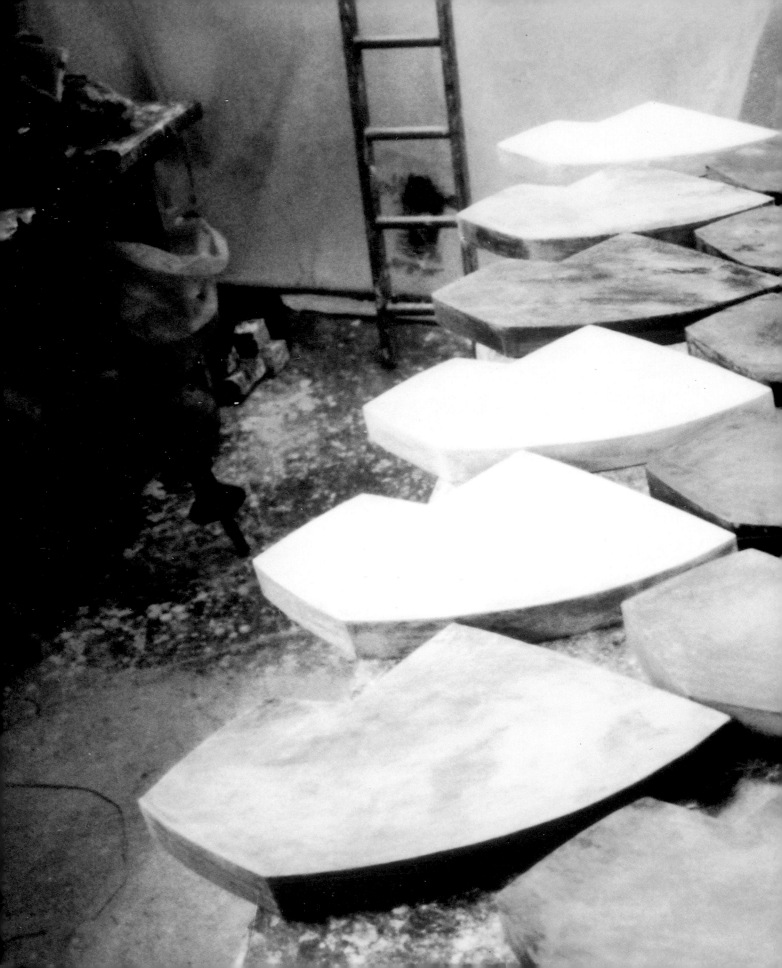

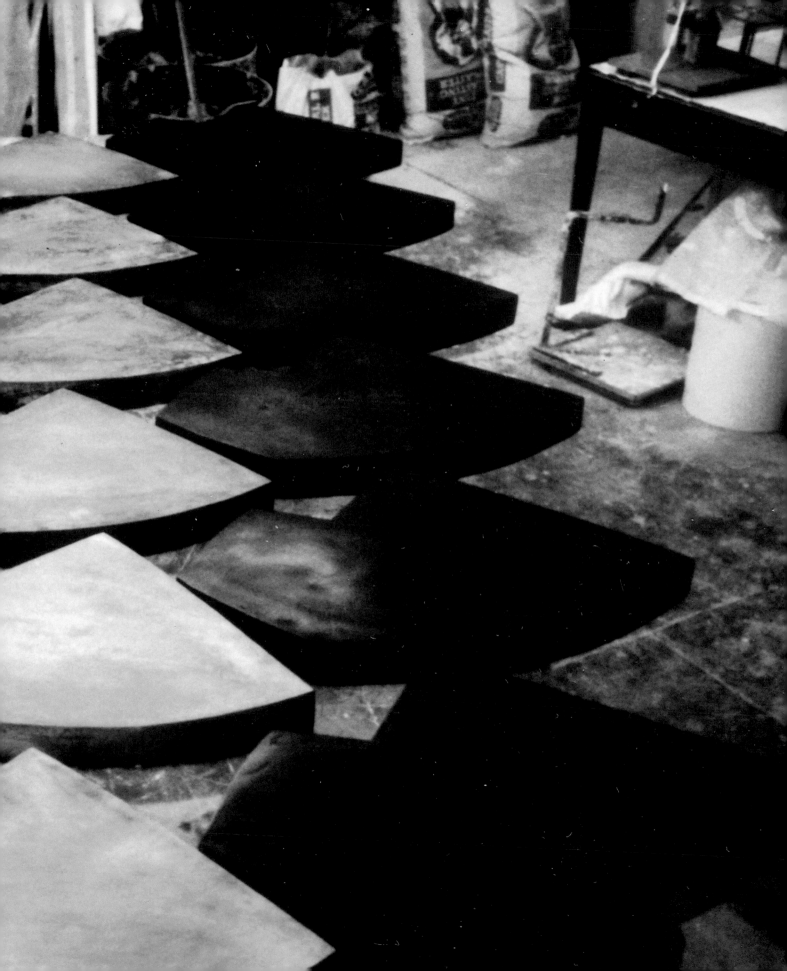

FAYE HIRSCH:
PLACING MEMORY
CATHERINE LEE'S ALPHABETS SERIES

"The sign must be the unity of a heterogeneity," wrote Jacques Derrida in *Of Grammatology*, "since the signified...is not in itself a signifier, a trace: in any case is not constituted in its sense by its relationship with a possible trace. The formal essence of the signified is presence, and the privilege of proximity to the logos...is the privilege of presence." What Derrida and many of his contemporaries in the French critical establishment sought to demonstrate was that the era of a necessary link between "signifier" and "signified" had passed — that, in fact, the reign of the Logos had passed, of the Judeo-Christian linkage of the Word and all elements of creation and the universe. The sign was not one, but many. While his study was of language and writing, the paradigm was a persuasive one from the standpoint of those writing about the visual arts, who could see (in what Arthur Danto has called the "post-historical art" era) that the relations between representation and the world were arbitrary at best, subject to forces not at all self-evident, and that, moreover, 20th-century modernism's claims to an airtight purity could not stand up to the variables of its materiality and its reception. From this vantage point, the seeds of destruction were "always-already" planted, whether after the advent of modernism or before. Language and images could be set free into a limitless play ("One could call play the absence of the transcendental signified," wrote Derrida), unhindered by the coercive force of a constituting origin, including — and this the art world still has difficulty stomaching — the author, or artist, herself.

Catherine Lee's Alphabets embody this chronic condition of "post-historical" art-making, characterized both by *jouissance* and all kinds of nostalgia, including the yearning for a unity (or unification) that might prove to be nothing other than the "unity of a heterogeneity." The work of art is not one, but many. Ostensibly, Lee's multiple and serial project seeks to "gather up" memory, to "place" it in relation to her biography and to the world. What she has found is that memory fragments can accumulate endlessly, and that attempts to link them to the work of art inevitably wind up in the infinite present and presentness of the object itself. Begun in 1987, the Alphabets, so-called for the fact that they are made in order, according to the letters of our alphabet, constitute three

series, the third still in progress. (The second series, from which are drawn the works in this exhibition, was made from 1991 to 1995.) When Lee made the first piece in the first series, *Aberystwyth*, in 1987, she was not thinking of much beyond it; but by 1988, she had conceived the idea of a series linked to places she had been, and ordered according to the letters of the alphabet. They really are memory pieces, the trace of the artist's peregrinations through the world

Tabasco, Mexico
Photo by Catherine Lee

— and she is a person who has traveled much, beginning her life as the child of a father in the military, and living it, to this day, restlessly.

The difficulty of establishing such a link, however, becomes evident even in the rules that govern the Alphabets' making. Their singular relation to the places they are tied to is, for one, undermined by that most variable and un-moored of factors, their titles: each piece is in an edition of four, and each of the four, identical in form though not in color, has a different title beginning with the same letter: *Altamira, Aberdeen, Aleutian Islands, Amarillo; Ballantrushal, Borders, Bangkok, Bering Sea*, etc. The four pieces are assembled in the same

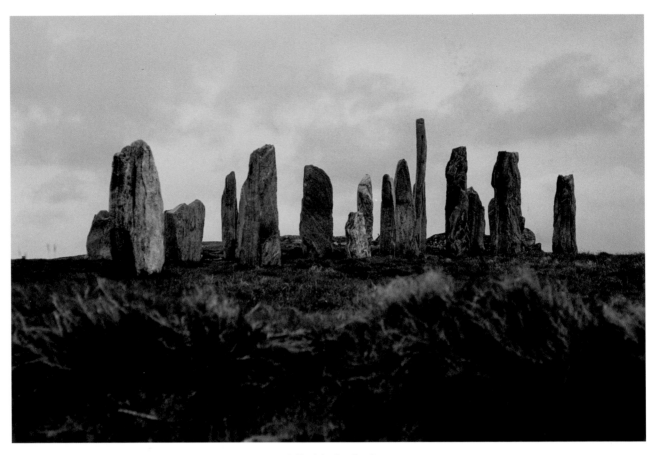

Callanish, Scotland
Photo by Catherine Lee

way of the same cast components. As written grapheme, an initial is just as concrete, visually, as a sculptural composition. And this is what each of the four shares: an initial, and a composition. Where the edition varies is in its patination and color, and, of course, its title: and this tips Lee's hand, for she conceives a linkage to a place and to the past purely through color. Letters of the alphabet give the series a framework, a direction in which to proceed, and composition a skeleton, a form; but color unhinges the form, altering it as ineluctably as the titular words, unfolding beyond their initial, open a realm of unmeasurable linguistic resonance. "The titles," Lee says "have to have an abstract interest" — as words, that is; and with a predominance of Mexican and Scottish place-names, they are, indeed, "colorful."

All of the Alphabets, which Lee now sees as a lifelong project and produces alongside her other series and individual works, are shaped pieces comprising two or more parts. Lee's compositions are not one, but many. Most are made of cast bronze, some of iron, "ancient materials, which she sets in the

artistic context of modernism," as David Carrier has written, and, indeed, as materials they are venerable, with their ancient associations exploited by Lee, who seems drawn, as well, to places with long, sometimes mystical histories. The prehistoric cromlechs of Callanish, black silhouettes in her photograph of the site, recall (perhaps influenced) the shape of the "C" by that name in the second series, with its hunched, dark silhouette adjoining a green counterpart. Her Alphabets are always multi-part, never single units, says Lee, because she needs the complexity of color she can only get with multi-part pieces. But it is also true that, while each work presents a distinctive profile, the fact remains that its already complex outline, never the simplest geometric form to begin with, is further problematized by the fissures that mark its interior borderlines. There is no necessary relationship between the outline of and the lines within the form. The meeting up may seem inevitable, but each section of the piece comes into contact with another as a discrete identity, however altered by the encounter. The piece is whole, but also always consisting of fragments that, despite their unification one with the other, remain fragmentary, the "unity of a heterogeneity."

A warning flag has been raised as to the diffuse relation of this work to the world, the establishment of which seems to be at its heart, and the digression from which constitutes its ambient of yearning and, paradoxically, its concreteness — a concreteness that is often remarked on in Lee's work ("The viewer is situated before it, in the room, on this spot, at this time," writes Stephen Westfall.) In fact, Lee's modus operandi for gathering the inspiring material for this work is as scattered as the locales. Lee has "visited" all the places named — that, too, is a rule — but sometimes only just driven through them in a peremptory way. The viewer never knows what these places mean to her, if anything, unless she tells: that Fort Sam Houston, for example, is where her father is buried; that the Aleutian Islands is where her son was conceived. Most lack such specific biographical associations, and her eventual "favorites" have nothing to do with the depth of her personal associations to the places named, but only to the work as it ended up. Her own memory of most of these places, she admits, is refracted many times, and the route circuitous, at best, from place to artwork via the shambles of memory. Sometimes she remembers a place because of the book she was reading when she drove through: she draws in her books and takes notes in them, so her library is a resource in a unique way. The abstract sketches in the books, however, rarely form the basis for the Alphabets named for the places they "record" — Lee's snapshots are, if anything, more useful to that end. She also sends friends and loved ones

handmade postcards with sketches in watercolor that, again, may or may not have a relationship to wherever she is touring, but are almost never used for the Alphabets of the places from which they are sent. (She keeps track of these cards, however, in a bound book in which she records all the cards she's sent and to whom.) Placing memory is a process fraught with numerous digressions.

If there exists any relationship with the place named, Lee emphasizes, it is established purely through color. But the slippery nature of color as a link between the interiority of the artist and the exteriority of the world has been long remarked on in visual art (viz. the Fauves or the Nabis). Lee insists the relation is quite "literal." "The meaning is always in the color, never in the form," she says. "Because the form is done without thinking of particular places." (Thus it can be four places at once!) "But the actual influence of places is only to do with the color. It's literal for me, as memories are." Yet when asked what, precisely, she means by this, she hedges. How literal are memories? Are these the colors of the cliffs? The sky and sea on a particular day? "Sometimes," she says. "But sometimes it is a more cryptic association. For *Rimini* it was the black and white dogs in the Piero della Francesca painting in Rimini" (*St. Sigismund and Sigismondo Pandolfo Malatesta*, which is in the Tempio Malatestiano). The dogs are only a detail at the bottom of the painting. Color, in other words, can be something not at all associated with a particular place, objectively speaking. The tiny detail that has fueled Lee's coloristic memory of a place can be so absurdly subjective that it serves not a whit to illuminate the "meaning" of the piece, in which color takes on an immediacy that has little to do with a place and time far removed from here and now. True, she wanted the starkness of the white on dark in *Fort Sam Houston* to be a very direct reference to the cemetery. "That Fort Sam Houston piece — that is a clear example to talk about as far as the place and the piece referring to each other." But mostly, the relationship is not so direct. The patinas are set in striking combinations, and surfaces burnished and otherwise worked to create atmospheric conditions on the skin of the piece — quite suggestive, but in a general way: the "sign" of something more than meets the eye, which is, however, always being fully met by the object at hand. If this is memory, then it is yet another in a series of mere coincidences for a viewer who seeks some sort of tie between the titular place and the object before the eyes. Somehow it makes sense, but in an accidental way, like the ways in which the disparate lines of the outline and the interior fissures come together to make a whole.

Lee's color delicately conjures what is far away in time and space, but it-self always remains indefinite. The interaction of her colors serves always to

Fort Sam Houston, Texas
Photo by Catherine Lee

qualify and complicate them, and they always suffer the interference of surface, which dulls their clarity and conveys the sensation of factors intervening. Yet, as shaped abstractions, these objects are concrete and very specific, expressing their own, formal ties to the past, to Minimalism and, more emphatically, to modernism in general, inevitably and significantly filtered as any other sort of memory. What Arthur Danto writes as characteristic of art in our time, that it lacks the "possibility of a narrative direction," could be said of Catherine Lee's Alphabets, despite their systematic unfolding, despite their relatively coherent appearance as objects clearly formed, as is all her work, out of a deep appreciation of abstraction in the era of modernism. That she is so open about their relativity, freely admitting that they are tied to factors outside the conditions of their own making, is one mark that Catherine Lee is an artist of her times. Whether seen as "post-historical" or post-signification, Lee's Alphabets embrace the open-ended relations to art history, representation, artistic intent, and subjectivity that have liberated art in our era.

THE ALPHABET SERIES
PLATES

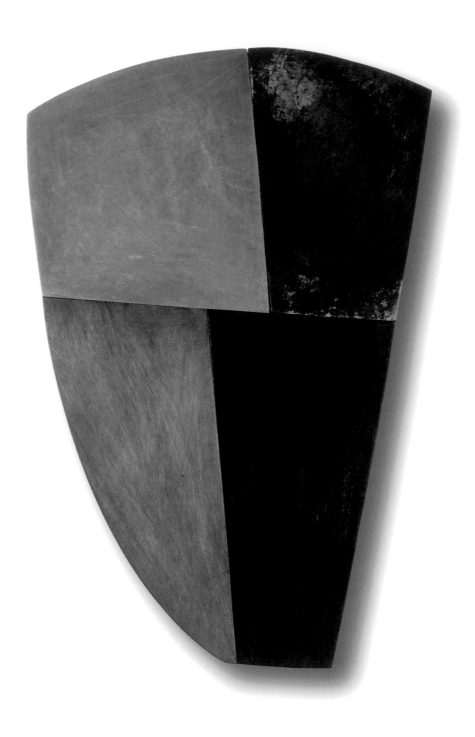

1. ALEUTIAN ISLANDS

1991
Cast bronze with patina. 20 x 13 x 2 inches

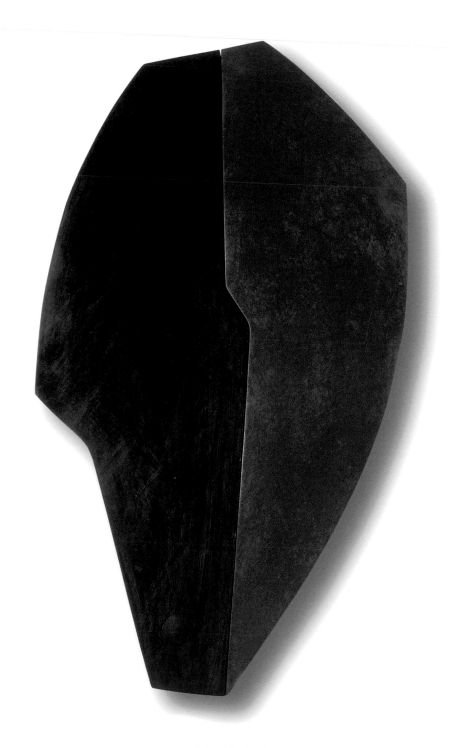

2. BALLANTRUSHAL

1991
Cast bronze with patina. 22 x 12.5 x 2 inches

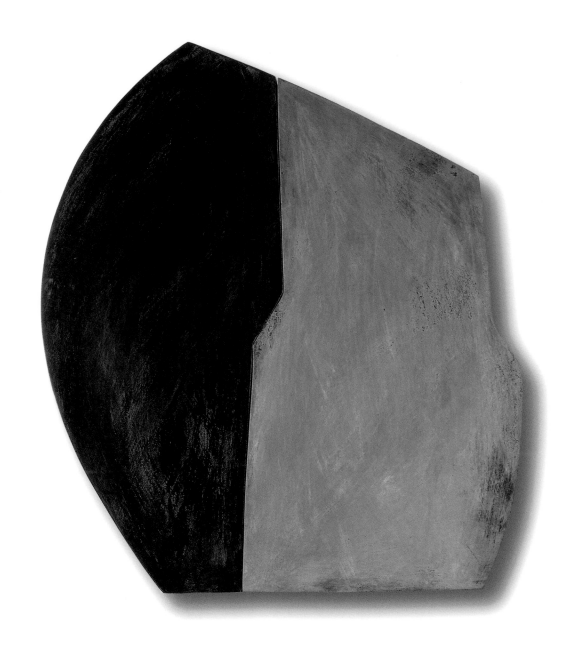

3. CALLANISH

1991
Cast bronze with patina. 21 x 18.5 x 2 inches

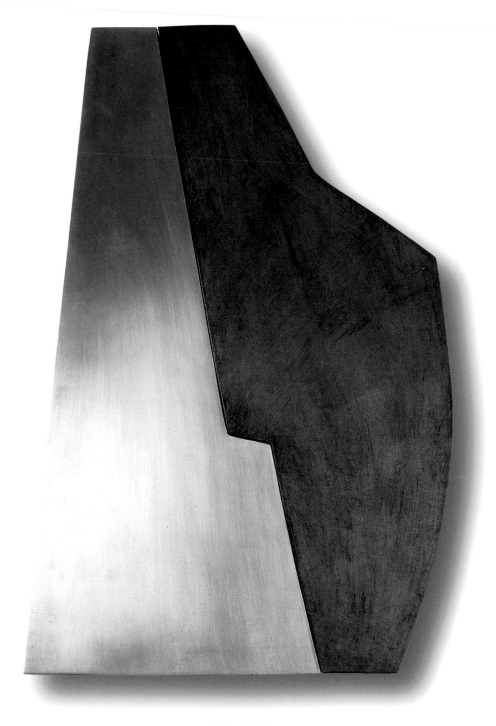

4. DUN LIATH

1991
Cast brass / cast copper. 19 x 13 x 2 inches

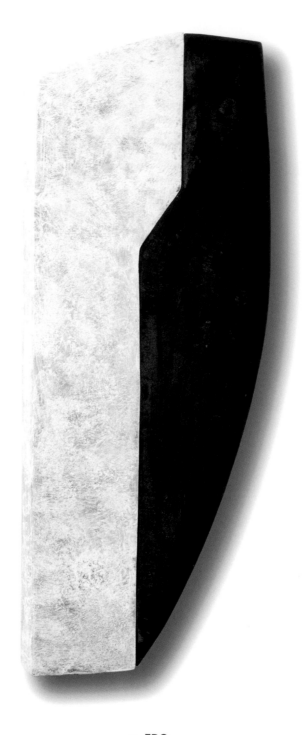

5. EDO

1991
Cast bronze with patina. 23 x 9 x 2 inches

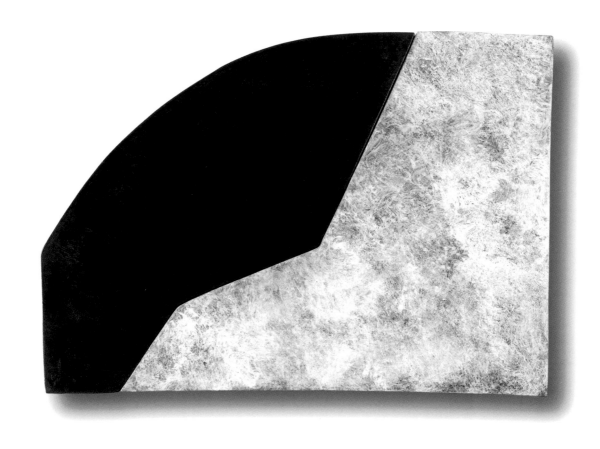

6. FORT SAM HOUSTON

1991
Cast bronze with patina. 9.5 x 13.5 x 2 inches

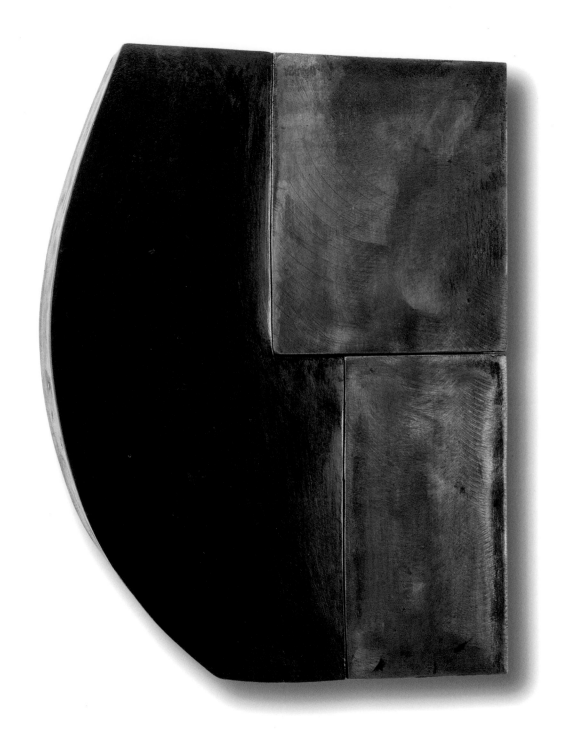

7. GARYNAHINE

1991
Cast bronze with patina. 16 x 12 x 2.5 inches

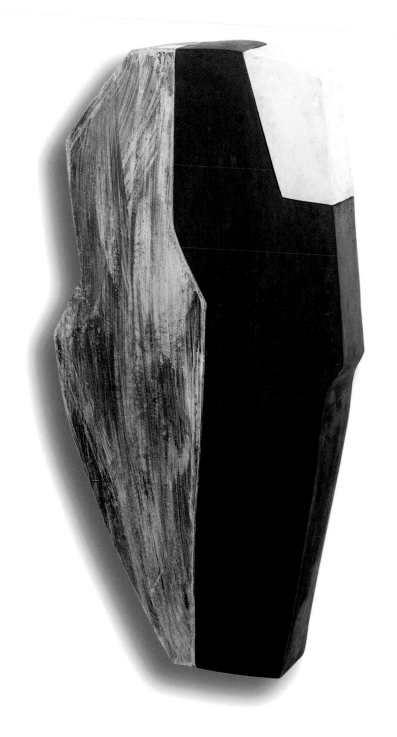

8. HADES

1992
Cast bronze with patina. 20.5 x 11 x 2 inches

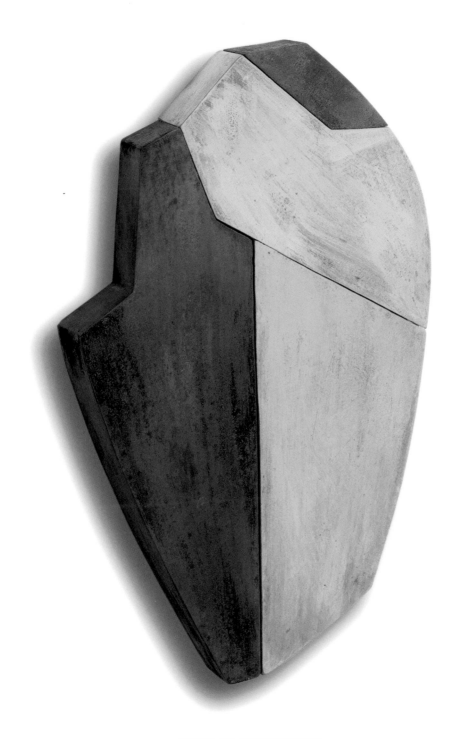

9. ISTMO DE TEHUANTEPEC

1992
Cast bronze with patina. 17.5 x 11 x 1.5 inches

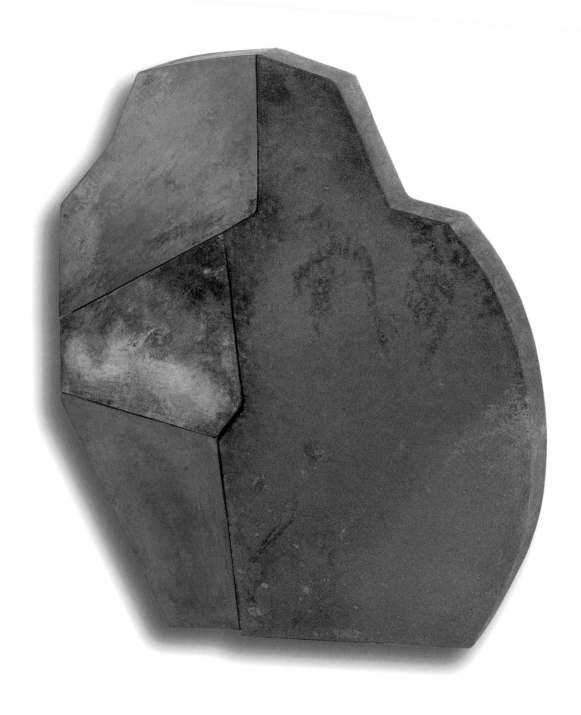

10. JOHNSTOWN

1992
Cast iron, oxidized and cast bronze with patina. 17 x 14.5 x 2.5 inches

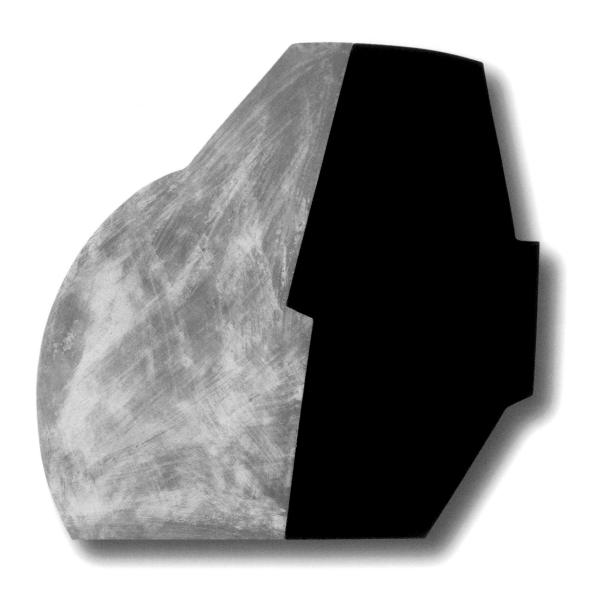

11. KENSALEYRE

1992
Cast bronze with patina. 16.5 x 16.5 x 3 inches

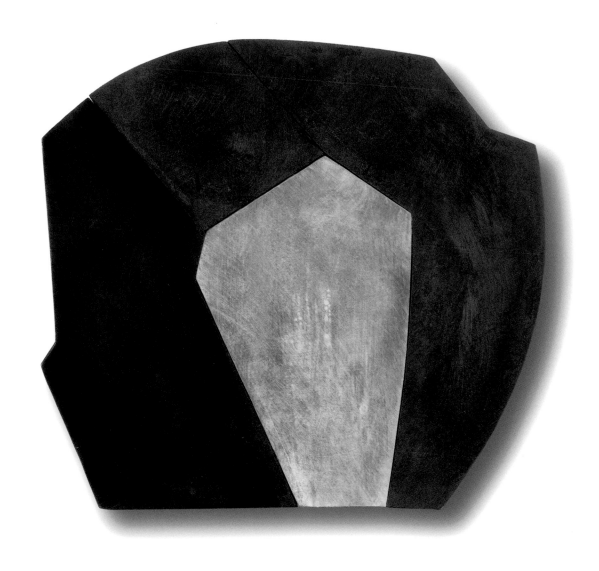

12. LEODHAS

1992
Cast bronze with patina. 11 x 12 x 1.5 inches

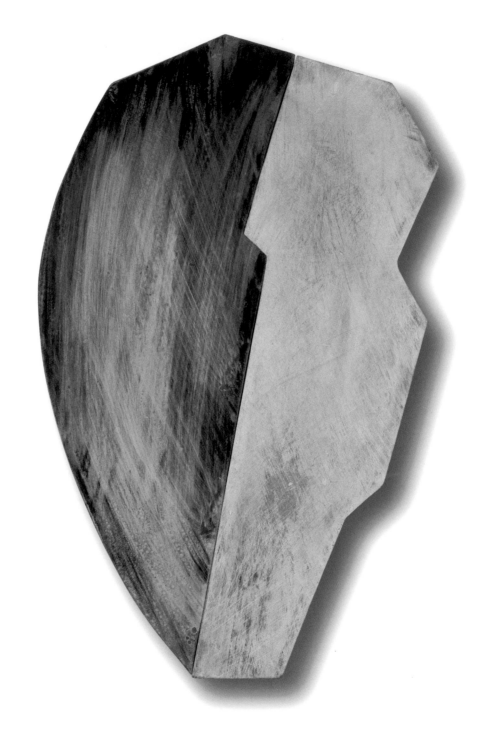

13. MOROCCO

1992
Cast bronze with patina. 20 x 12 x 2 inches

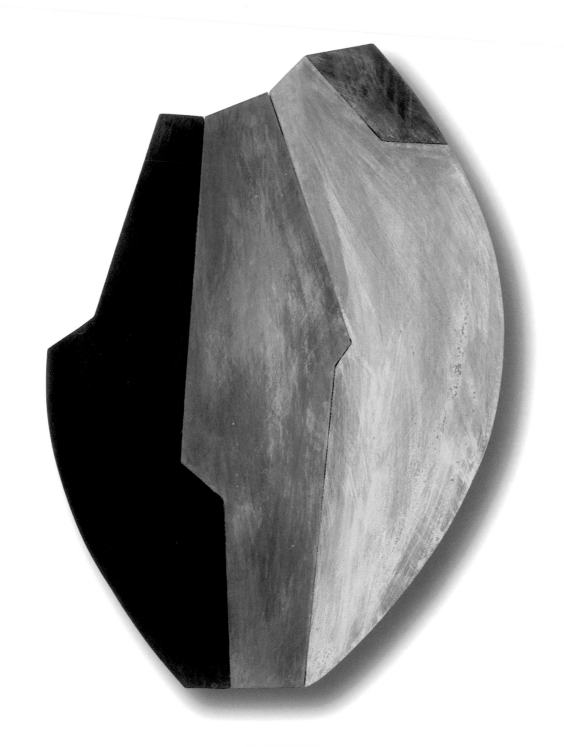

14. NA HEARADH

1993
Cast bronze with patina. 20 x 14 x 2.5 inches
Private collection, New York

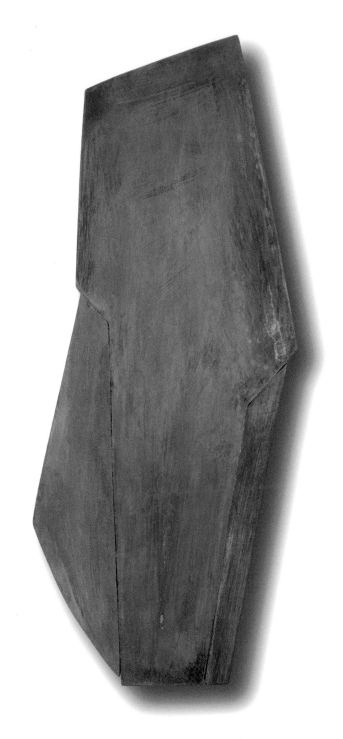

15. OZONA

1993
Cast bronze with patina. 22.5 x 9 x 3 inches

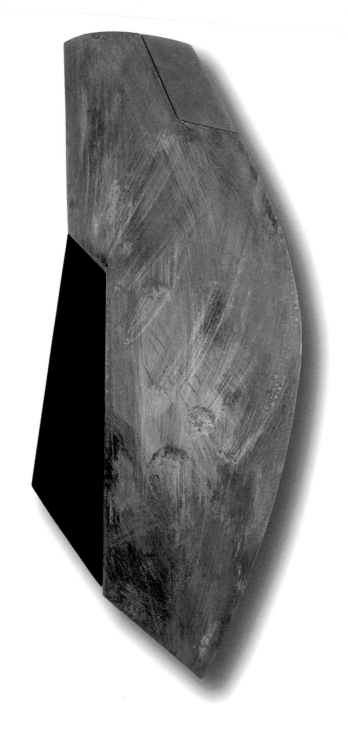

16. PACHUCA

1993
Cast bronze with patina. 20.5 x 9 x 3 inches

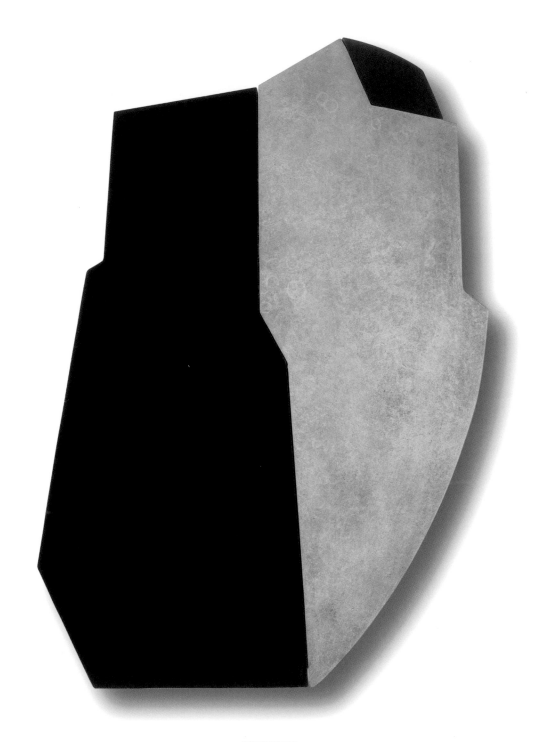

17. QUEMADO

1993
Cast bronze with patina. 17 x 11.5 x 2 inches

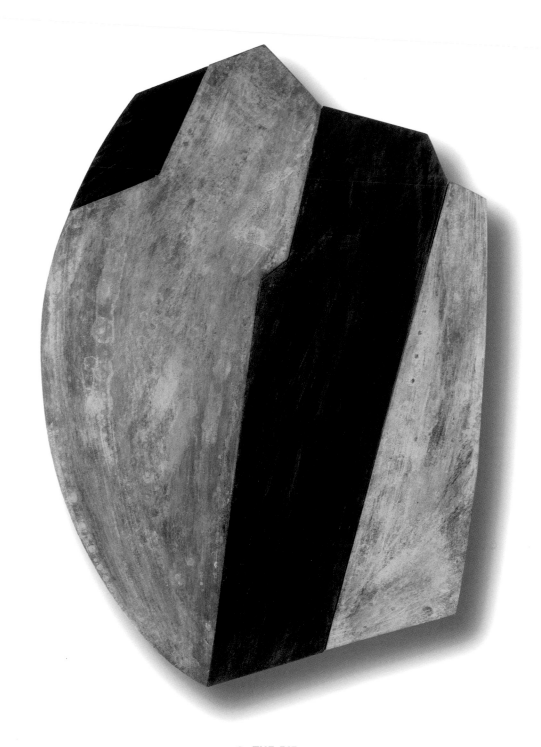

18. THE RIF

1993
Cast bronze with patina. 19 x 13.5 x 2.5 inches

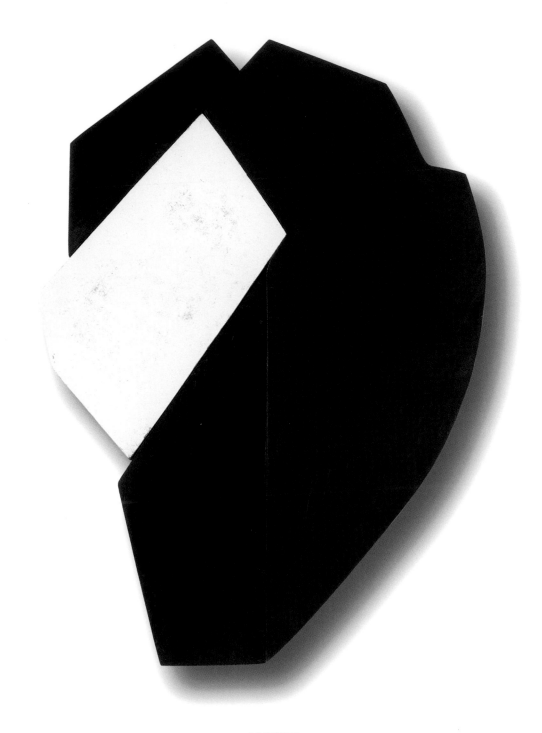

19. SCARISTA

1993
Cast bronze with patina. 11.5 x 8 x 2 inches

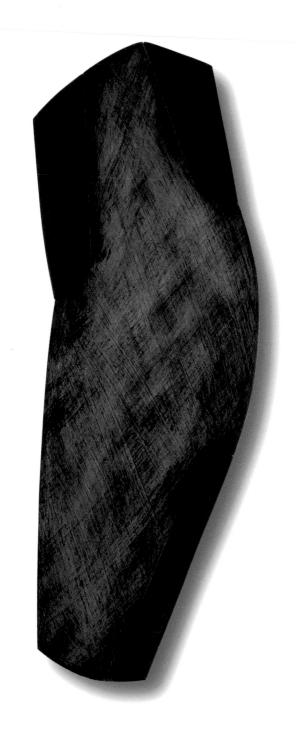

20. TABASCO

1993
Cast bronze with patina. 21.5 x 9 x 3 inches

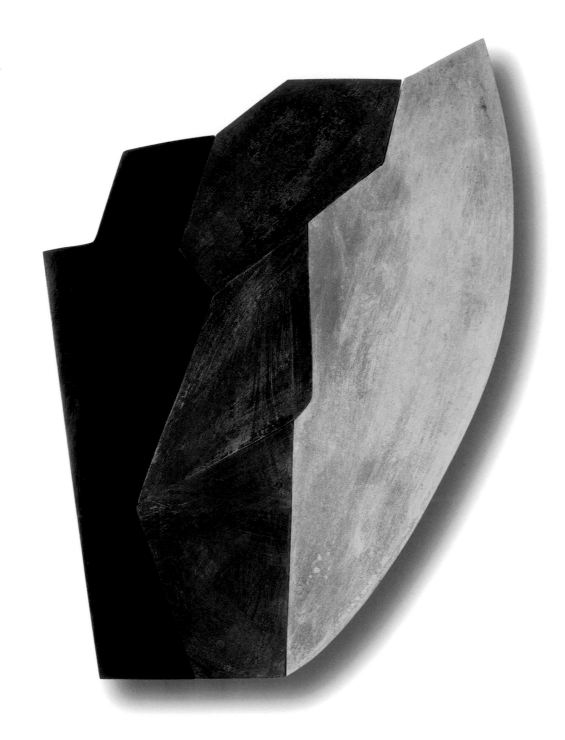

21. UTE

1993
Cast bronze with patina. 17 x 12 x 2.5 inches

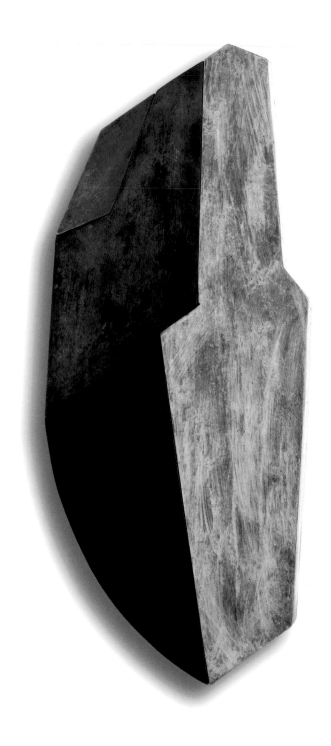

22. VIZCAYA

1994
Cast bronze with patina. 20 x 8.5 x 2 inches

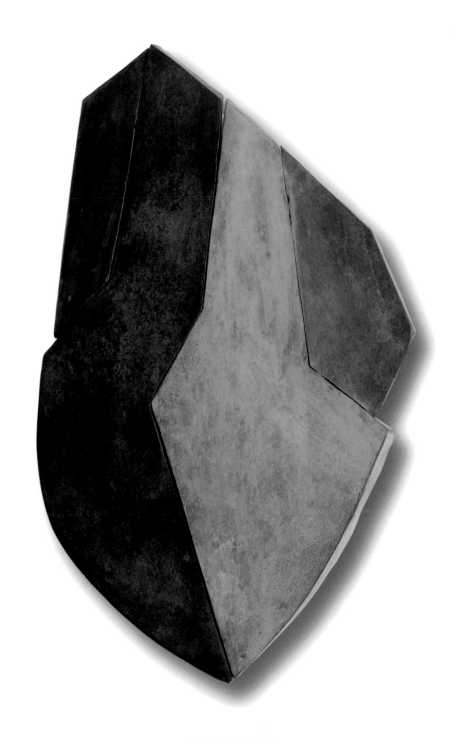

25. YOUNGSTOWN

1995
Cast bronze with patina. 11 x 7 x 1 inches

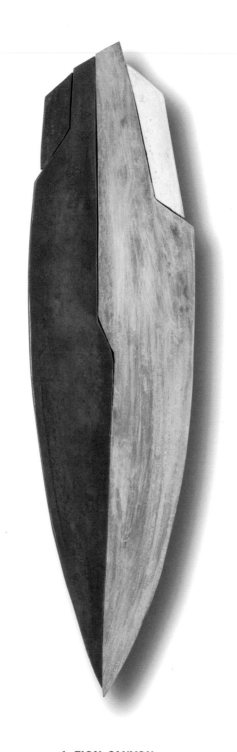

26. ZION CANYON

1995
Cast bronze with patina. 21 x 5 x 1 inches

CATHERINE LEE
BIOGRAPHY AND BIBLIOGRAPHY

ONE PERSON EXHIBITIONS

1980	P. S.1. , New York
1983	The University of Texas, San Antonio
1984	John Davis Gallery, Akron
1985	Gallery Bellman, New York
	John Davis Gallery, Akron
1986	John Davis Gallery, New York
1987	John Davis Gallery, New York
1988	Michael Maloney Gallery, Santa Monica
1989	Annely Juda Fine Art, London
	Thomas Segal Gallery, Boston
1990	Marisa del Re Gallery, New York
	Galerie Karsten Greve, Paris
	Gallery Kasahara, Osaka
	Stephen Wirtz Gallery, San Francisco
1991	Galerie Jamileh Weber, Zürich
	Galerie Karsten Greve, Köln
	Kohji Ogura Gallery, Nagoya
1992	Städtische Galerie im Lenbachhaus, Munich
	Neue Galerie der Stadt Linz, Linz
	Galleri Weinberger, København
1993	Galerie Lelong, New York
	Annely Juda Fine Art, London
	Limestone Press, San Francisco
1994	Hill Gallery, Birmingham, Mi.
1995	Galerie Karsten Greve, Paris
	Galleri Weinberger, København
	Galerie Lelong, New York City
	Galerie Karsten Greve, Köln
	Mizuma Gallery, Tokyo
1996	Galerie Academia, Salzburg
	Galerie Jamileh Weber, Zürich
1997	Galerie Karsten Greve, Milano
1998	Galerie Karsten Greve, Köln
	Galleri Weinberger, København
1999	Galerie Lelong, New York City

SELECTED GROUP EXHIBITIONS

1978 *Four Artists*, curated by Per Jensen, Nobe Gallery, NYC
 Summer Invitational, Nobe Gallery, NYC

1979 *New Wave Painting*, curated by Per Jensen, The Clocktower, NYC
 Fourteen Painters, Lehman College, CUNY, NYC

1980 *Mind Set*, John Weber Gallery, NYC
 Contemporary Works, curated by Sam Hunter, Princeton
 University Museum, Princeton, NJ

1981 *CAPS at the State Museum*, New York State Museum, Albany
 Arabia Felix, curated by William Zimmer, Art Galaxy, NYC
 New Directions, curated by Sam Hunter, traveling exhibition:
 The Museum of Art, Ft. Lauderdale, FL
 Oklahoma Museum of Art, Oklahoma City, OK
 Santa Barbara Museum of Art, Santa Barbara, CA
 Grand Rapids Art Museum, Grand Rapids, MI
 Madison Art Center, Madison, WI
 Montgomery Museum of Fine Art, Montgomery, AL

1982 *Critical Perspectives*, curated by Joseph Masheck, P.S.1, NYC
 Group Invitational, Sunne Savage Gallery, Boston
 Pair Group, curated by William Zimmer, Jersey City Museum of Art,
 Jersey City, NJ
 Pastiche, Emily Harvey Gallery, NYC

1983 *New Acquisitions*, Franklin Furnace, NYC
 All Over Painting, Grommet Gallery, NYC
 MCAD Faculty Show, Minneapolis College of Art & Design, Institute
 of Art, Minneapolis, MN
 Third Anniversary Exhibition, John Davis Gallery, Akron, OH
 Contemporary Abstract Painting, Muhlenberg College Center for the
 Arts, Allentown, PA
 Multiples, Jack Tilton Gallery, NYC

1984 *Exhibition of Contemporary Art*, Merrill Lynch Pierce Fenner &
 Smith, Inc, Akron, OH
 Contemporary Art, National City Bank, Cleveland, OH
 Fifteen Abstract Painters, curated by Per Haubro Jensen, Susan
 Montezinos Gallery, Philadelphia, PA
 Small Works: New Abstract Painting, Lafayette College, Easton, PA
 Fourth Anniversary Exhibition, John Davis Gallery, Akron, OH
 Acquisition Priorities, curated by Laurie Rubin, William Beadleston
 Gallery, NYC
 Summer Group Show, Gallery Bellman, NYC

1985 *The Non-Objective World - 1985*, curated by Stephen Westfall,
 Kamikaze, NYC

An Invitational, curated by Tiffany Bell, Condeso-Lawler Gallery, NYC

Fifth Anniversary Exhibition, John Davis Gallery, Akron, OH

1986　*Inaugural Exhibition*, John Davis Gallery, NYC

Catherine Lee and Sean Scully, Paul Cava Gallery, Philadelphia

Past and Present, curated by Steven Reynolds, University of Texas,
　　San Antonio, TX

Gallery Artists, John Davis Gallery, NYC

Invitational, Saxon Lee Gallery, Los Angeles

Works on Paper, Althea Viafora Gallery, NYC

Art on Paper, Weatherspoon Art Gallery, University of North Carolina,
　　Greensboro, NC

24 x 24, Ruth Siegel Gallery, NYC

The Constructed Image, Laurie Rubin Gallery, NYC

1987　*Lee, Lewczuk, Witek,* Pamela Auchincloss Gallery, Santa Barbara, CA

5 Abstract Artists: Amar, Gitlin, Glick, Lee, Wiley, Michael Maloney
　　Gallery, Santa Monica, CA

Gallery Artists, John Davis Gallery, NYC

Monotypes from the Garner Tullis Workshop, Laurie Rubin Gallery, NYC

Art Against Aids, Rosa Esman Gallery, NYC

Drawn Out, Kansas City Art Institute, MO

Black in the Light, Genovese Graphics, Boston

Selected Works, Albright-Knox Museum, Buffalo, NY

1988　*Ten Americans*, curated by John Caldwell, Museum of Art, Carnegie
　　Institute, Pittsburgh, PA

Collaborations in Monotype, curated by Phyllis Plous, traveling
　　exhibition: University Art Museum, Santa Barbara, CA
　　Huntington Gallery, University of Texas, Austin, TX
　　Cleveland Museum of Art, Cleveland, OH

Works from the Garner Tullis Workshop, Thomas Segal Gallery, Boston

Works on Paper: Selections from the Garner Tullis Workshop, Pamela
　　Auchincloss Gallery, NYC

Seven American Abstract Artists, Ruggiero-Henis Gallery, NYC

40th Annual Academy Institute Exhibition, American Academy and
　　Institute of Arts and Letters, NYC

Works on Paper Invitational, Shea & Beker Gallery, NYC

Works on Paper, Ruggiero-Henis Gallery, NYC

1989　*Sitings: Drawing with Color,* traveling exhibition:
　　Instituto de Estudios Norteamericanos, Barcelona
　　Casa Revilla, Valladolid, Spain
　　Museo Barjola, Gijon, Spain
　　Calouste Gulbenkian Foundation, Lisbon, Portugal
　　Pratt Manhattan Gallery, NYC
　　Schafler Gallery, Pratt Institute, NYC

Monotypes from the Garner Tullis Workshop, Zolla-Lieberman
 Gallery, Chicago
Small Paintings, Nina Freudenheim Gallery, Boston
Monotypes from the Garner Tullis Workshop, Persons-Lindell Gallery,
 Helsinki
Drawings, Stephen Wirtz Gallery, San Francisco
Geometry and Abstraction, curated by Pamela Auchincloss, Persons-
 Lindell Gallery, Helsinki
Recent Acquisitions, Prints and Monotypes, The Tate Gallery, London
18th International Biennale of Graphic Art, International Centre of
 Graphic Art, Ljubljana, Yugoslavia

1990 *Monotypes from the Garner Tullis Workshop*, Malmgran Gallery,
 Göteborg, Sweden
 Inaugural Exhibition, Stephen Wirtz Gallery, San Francisco
 Minimal Sculpture, Marisa del Re Gallery, NYC
 Artists in the Abstract, curated by John Davis, Weatherspoon Art
 Gallery, University of North Carolina, Greensboro, NC

1991 *Drawings*, Pamela Auchincloss Gallery, NYC
 Group Exhibition, Marisa del Re Gallery, NYC
 Contemporary Sculpture from the Weatherspoon Collection,
 Weatherspoon Art Gallery, University of North Carolina,
 Greensboro, NC
 Catherine Lee Monotypes, Pamela Auchincloss Gallery, NYC
 IIIème Biennale de Sculpture, Monte Carlo, Monaco
 Art for Children's Survival, Unicef, Lawrence Monk Gallery, NYC

1992 *The Age of Bronze*, Ramnarine Gallery, NYC
 Geteilte Bilder, Das Diptychon in der neuen Kunst, Museum
 Folkwang, Essen, Germany
 Reliefs, Konstructive Tendens, Stockholm
 Monotypes from the Garner Tullis Collection, Carpenter Center for
 the Visual Arts, Harvard University, Cambridge
 Women Critics, Bruton Street Gallery, London
 Curated by Bill Maynes, Boshart Gallery, Old Chatham, NY
 Juxtapositions, Annely Juda Fine Art, London

1993 *Italia - America, L'astrazione Ridefinita*, Galleria Nazionale d'Arte
 Moderna, San Marino, Italy
 Couples, Annely Juda Fine Art, London
 Garner Tullis Workshop, Jan Weiner Gallery, Kansas City, MO
 Contemporary Prints, Ten Years of Acquisitions, Cleveland Museum of
 Art, Cleveland, OH
 Prints from the Garner Tullis Workshop, The Australian Print Workshop
 & the Darian Knight Gallery, Fitzroy, Australia

Drawings, 30th Anniversary Exhibition, The Foundation for
 Contemporary Performance Art, Leo Castelli Gallery, NYC
5 One Man Shows, Galerie Jamileh Weber, Zürich

1994 *Shape*, Pamela Auchincloss Gallery, NYC
Contemporary Prints, The Tate Gallery, London
29th Annual Exhibition of Art on Paper, Weatherspoon Art Gallery,
 University of North Carolina at Greensboro, NC
Sculpture & Drawing, Galerie Lelong, NYC

1995 *Summer Group Show*, Galerie Jamileh Weber, Zürich
Group Show, Galerie Lelong, NYC
Black & White, Galleri Weinberger, København
U S Print / Grafiikkaa U S A, Garner Tullis Workshop, Retretti Art
 Center, Finland
Recent Acquisitions, Hofstra Museum, Emily Lowe Gallery,
 Hempstead, NY

1996 *Jill Moser & Catherine Lee*, University of Rhode Island
Serienbilder - Bilderserien, Städtische Galerie im Lenbachhaus, Munich

1997 *Gallery Group Exhibition*, parts I & II, Jamileh Weber Gallery, Zürich
New Editions, Galerie Lelong, NYC

1998 Group Show: Chillida, Judd, Lee, LeWitt, Mangold, Ryman,
 Galerie Lelong, NYC
 Group Exhibition, Galerie Karsten Greve, Paris

SELECTED PUBLIC COLLECTIONS

Städtische Galerie im Lenbachhaus, Munich
Museum of Modern Art, NYC
The Metropolitan Opera, NYC
Graphische Sammlung Albertina, Vienna
Cleveland Museum of Art
The Tate Gallery, London
The San Francisco Museum of Art
Vancouver Art Gallery, British Columbia
Neue Galerie der Stadt Linz, Austria
Milwaulkee Art Museum
Museum of Art, Carnegie Institute, Pittsburgh
Edward R. Broida Trust, Los Angeles
United States Department of State, Washington, D.C.
State University of New York, Cortland
Kenan Center, Lockport, NY
Buscaglia-Castellani Art Gallery, Niagara University, NY
Weatherspoon Art Gallery, University of North Carolina
Museet for Modern Kunst, København

SELECTED BIBLIOGRAPHY

Hilton Kramer, *The New York Times*, December 14, 1979

John Russell, *The New York Times*, July 19, 1981

Sam Hunter, *New Directions*, 1981, Museum of Art, Ft Lauderdale*

Robert C. Morgan, 'Abstract Painting, the New Pictorialism', *New Directions*, 1981, Museum of Art, Ft Lauderdale*

Daniel Grant, *Newsday*, February 28, 1982 (photo)

Vivian Raynor, *The New York Times*, October 10, 1982

Jan Tips, *San Antonio Express News*, May 1, 1983

William Zimmer, *Catherine Lee*, University of Texas, 1983*

John Russell, *The New York Times*, May 11, 1984

David Carrier, 'Catherine Lee', *Arts Magazine*, Summer 1984

Vivian Raynor, *The New York Times*, July 26, 1985

'Centennial Exhibition', MCAD, Minneapolis Institute of Art, 1985*

Steven Reynolds, *Texans Past and Present*, University of Texas, 1986*

John Russell, *The New York Times*, May 2, 1986

John Russell, 'Bright Young Talents', *The New York Times*, May 18, 1986

Kay Larson, *New York Magazine*, May 19, 1986

Tiffany Bell, *Arts Magazine*, Summer 1986

David Carrier, *Art in America*, October 1986

'Catherine Lee', John Davis Gallery, 1986*

John Russell, *The New York Times*, April 17, 1987

Barry Schwabsky, *Arts Magazine*, Summer 1987

John Caldwell, *Ten Americans*, Carnegie Museum of Art, 1987*

Phyllis Plous, 'Monotypes Today', *Collaborations in Monotype*, University Art Museum, University of California, Santa Barbara, CA, 1988*

Cathy Curtis, *The Los Angeles Times*, July 1, 1988

Susan Tallman, 'The Woodcut in the Age of Mechanical Reproduction', *Arts Magazine*, January 1989

Stephen Westfall, 'Catherine Lee', Annely Juda Fine Art, 1989*

Mary Rose Beaumont, *Arts Review*, March 24, 1989

William Feaver, *The Observer*, London, April 12, 1989

Pamela Auchincloss, 'Geometry and Abstraction', Persons-Lindell Gallery, Helsinki, 1989*

Timo Valjafka, *Helsingin Sanomat*, Helsinki, December 6, 1989

Dan Sundell, *Hufvudstadsbladet*, Helsinki, December 11, 1989

Susan Tallman, 'Contemporary Woodblock Prints', Jersey City Museum, NJ, 1989*

'XX Century Sculptures', Galerie Academia, Salzburg, 1990*

Peggy Cyphers, *Arts Magazine*, March 1990

Frances de Vuono, *Art News*, May 1990

Walter Thompson, *Art in America*, June 1990

David Carrier, *Art International*, Summer 1990

Geraldine Norman, *The Independent*, London, September 24, 1990

'Height Width Length', Weatherspoon Art Gallery, University of
 North Carolina, 1991*

Anne Rüegsegger, 'Catherine Lee', *Artis*, May 1991

Petra Kipphof, *Journal*, January 1992

Robert C. Morgan, 'The New Endgame', *Tema Celeste*, February 1992

Demetrio Paparoni, 'A Conversation with Catherine Lee', *Tema Celeste*,
 February 1992, English edition

David Carrier, 'The Life of Forms in Catherine Lee's Art', *Outcasts, New
 Works by Catherine Lee*, Städtische Galerie im Lenbachhaus,
 München 1992*

Helmut Friedel, 'Catherine Lee', *Outcasts, New Works by Catherine Lee*,
 Städtische Galerie im Lenbachhaus, München, 1992*

Claudia Jaeckel, 'Die Freiheit des Geistes', *Süddeutsche Zeitung*,
 München, also Ebersberg, Starnberg, Bad Töls May 26, 1992

Barbara Reitter, 'Catherine Lee im Lenbachhaus', *Donau-Kurier*,
 May 22, 1992

Gert Gliewe, 'Catherine Lee im Lenbachhaus', *Abendzeitung*, München,
 June 2,1992

Barbara Reitter, 'Mit Sauer und Feuer', *Bayerische Staatszeitung*,
 München, June 12, 1992

Maribel Koniger, 'Catherine Lee', *Tema Celeste*, Autumn 1992

Catherine Lee, 'The Question of Gender in Art', *Tema Celeste*,
 Autumn 1992

Torben Weirup, 'En Amerikaner i København', *Berlingske Tidende*,
 November 22, 1992

Oystein Hjort, 'Forfinet Forhold til Farven', *Politiken*, København,
 December 8, 1992

Peter Klimitsch, 'Austellung, Catherine Lee', *Kurier*, Linz, Austria,
 December 3, 1992

Peter Moseneder, 'Ausgestossen', *Nachrichten*, Linz, December 4, 1992

Jacqueline Brody, *The Print Collector's Newsletter*, July/August 1992

Sister Wendy Beckett, 'Art and the Sacred', 1992, Random Century,
 Sydney, Australia

Gerhard Finckh, *Geteilte Bilder - Das Diptychon in der neuen Kunst*,
 Museum Folkwang, Essen, 1992*

Elio Cappuccio, 'Verso Bisanzio, Con Disincanto', Sergio Tossi Arte
 Contemporanea, Prato, Italy, 1992*

David Carrier, 'La vita delle forme nell'arte di Catherine Lee', *Titolo*,
 Perugia, Autumn 1992

Catherine Lee, Annely Juda Fine Art, London 1993*

William Feaver, 'Catherine Lee', *The Sunday Observer*, London,
 March 21, 1993
Gill Saunders, 'Sculpture with it's Back to the Wall', *Women's
 Art Magazine*, London, May 1993
Enrique Juncosa, 'Catherine Lee', *Lapiz*, Madrid, May 1993
Catherine Lee, Galerie Academia, Salzburg, Austria 1993*
'Catherine Lee', *The Print Collector's Newsletter*, July/Aug 1993
Danile Kurjakovic, 'Frischer Wind von Westen', *Zürichsee-Zeitung*,
 September 11, 1993
Demetrio Paparoni, 'The Self-Regulation of the System', *Italia-America*,
 L'astrazione Ridefinita, Galleria Nazionale d'Arte Moderna,
 San Marino, Italy 1993*
Carla Steininger, 'Back to the Elementary Prerequisites of Art',
 Salzburger Nachrichten, April 15, 1993
Partners, Annely Juda Fine Art, London 1993*
David Carrier, 'Italia-America', *Segno*, Pescara, Italy, summer 1993
Arturo Schwartz, 'Una Mostra da Non Perdere', *Segno*, summer 1993
Angelo Trimarco, 'Italia-America', *Tema Celeste*, autumn 1993
Hans W. Langwallner, 'Ex Nihilo. Day and Night', *Nike*, München,
 August 1993
Faye Hirsch, 'Catherine Lee at Galerie Lelong', *Art in America*,
 September 1993
Daniel Kurjakovic, 'Frischer Wind von Westen', *Zurichsee-Zeitung*,
 Sept 11, 1993
Judith Trepp, 'Zurich, 5 One man Shows', *Art News*, January, 1994
'La Differenzia Tra i Sesi Nell'Arte', *Tema Celeste*, winter 1994
Marsha Miro, 'Painting and Sculpture', *Detroit Free Press*,
 March 11, 1994
David Carrier, 'Studio: Catherine Lee', *Sculpture*, November 1994
Eva Pohl, 'Infinity in Perspective', *Berlingske Tidende*, January 20, 1995
Oystein Hjort, 'Between Sculpture and Painting', *Politiken*, København,
 February 3, 1995
Marjaana Toiminen, 'Retretin Kesa: U. S. Print', *Grafiikanlehti*, Finland,
 May 23, 1995
Helmut Friedel, 'Color is Indeed a Body', Mizuma Gallery,
 Tokyo, 1995*
'Catherine Lee', *Sankei*, Tokyo, December 31, 1995
Emily Rait, 'Recent Acquisitions 1991-1995', Hofstra Museum, 1995*
Pepe Karmel, *The New York Times*, January 5, 1996
Wolfgang Richter, 'Im Dialog der Elemente das Mass feiner
 Poesie', *Salzburger Nachrichten*, April 18, 1996
Geijutsu Shincho, edition #2, Tokyo, 1996
* denotes catalog

Copyright © 1997 Pamela Auchincloss, Arts Management, New York.
Texts © 1997 Carter Ratcliff and Faye Hirsch.
Works by Catherine Lee © Catherine Lee.

Second Edition

Distributed by University of Washington Press
P.O. Box 50096, Seattle, WA 98145

Edited and produced by Pamela Auchincloss, Arts Management, New York.
Designed by Vagn Henriksen and Pura Vida, Copenhagen, Denmark.
Printed by C & C Offset Printing Co., Ltd., Hong Kong. Edition of 1000.

Unless otherwise indicated all works are courtesy of the artist.
Courtesy of Galerie Lelong, New York: Text illustration 6, 17; plate illustrations 17, 18, 22, 25, 26
Courtesy of Galerie Karsten Greve, Köln: Text illustrations 2, 5, 7, 8, 12, 20, 21
Courtesy of Galerie Jamileh Weber, Zürich: Text illustrations 13, 18
Courtesy of Annely Juda Fine Art, London: Text illustration 10
Courtesy of Galleri Weinberger, København: Text illustrations 3, 9
Courtesy of Galerie Academia, Salzburg: Text illustration 15
Courtesy of Gallery Mizuma, Tokyo: Text illustration 11
Courtesy of Galeria Carles Taché, Barcelona: Text illustration 22, 23

Unless otherwise indicated photography of the artist's work by Catherine Lee.
Dennis Barna: Text illustrations 3,4,5,6,7,8,9,10,11,12,13,14,15,16,17,18,19,20,22;
plate illustrations 1,2,3,4,6,7,8,9,10,11,13,14,15,16,17,18,19,20,21.
John Riddy: Text illustration 2; plate illustrations 5,12.
Ray Ballheim: Text illustration 1; plate illustrations 22,23,24,25,26.

Pages 4-5: the artist's studio, London. Photo © 1990 Catherine Lee
Pages 28-29: Catherine Lee, *Strata* (detail), 1992,
cast bronze with patina, 96 x 152 x 2 1/2 inches, courtesy Galerie Jamileh Weber, Zürich.
Page 36: Catherine Lee, *Lead Constellation* (detail), 1990,
cast lead, 87 x 96 x 3 inches, private collection, Zürich.
Page 66, portrait of the artist. Photo © 1997 Parker Valentine.
Page 76-77, the artist's studio, Texas. Photo © 1997 Sean Scully.

All metal work cast at Lockbund Sculpture, Cropredy, Oxfordshire and at Empire Bronze Art Foundry, Long Island City.

We would also like to thank the following individuals and organizations for their generous support of this exhibition: Sean Scully, Igor Foundation, Vagn Henriksen, Steen Bundgaard, Mary Sabbatino, and especially Parker Valentine.

Library of Congress Cataloging-in-Publication Data
Lee, Catherine, 1950 -
Catherine Lee, The Alphabet Series and Other Works/Carter Ratcliff/Faye Hirsch.
ISBN 0-9659746-0-X (paper)

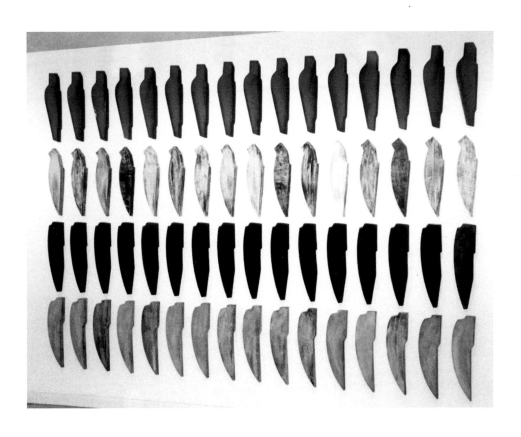

24. Inner Voices, 1992
Cast iron, bronze, lead, copper. 76 x 93 x 2 inches
Private collection, Copenhagen

75

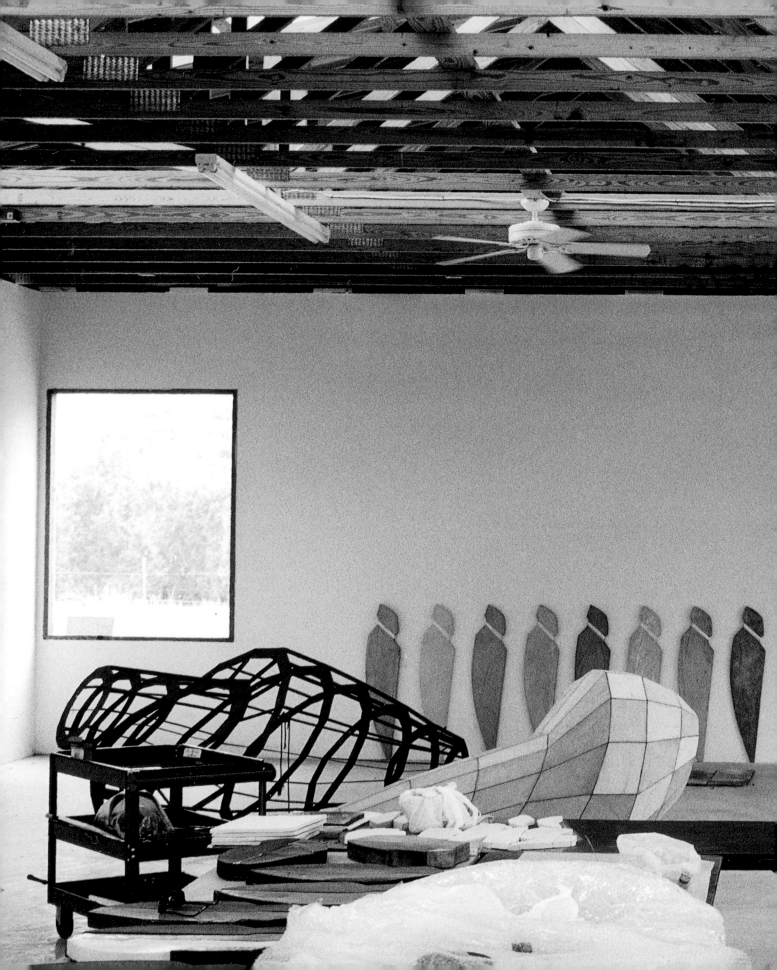

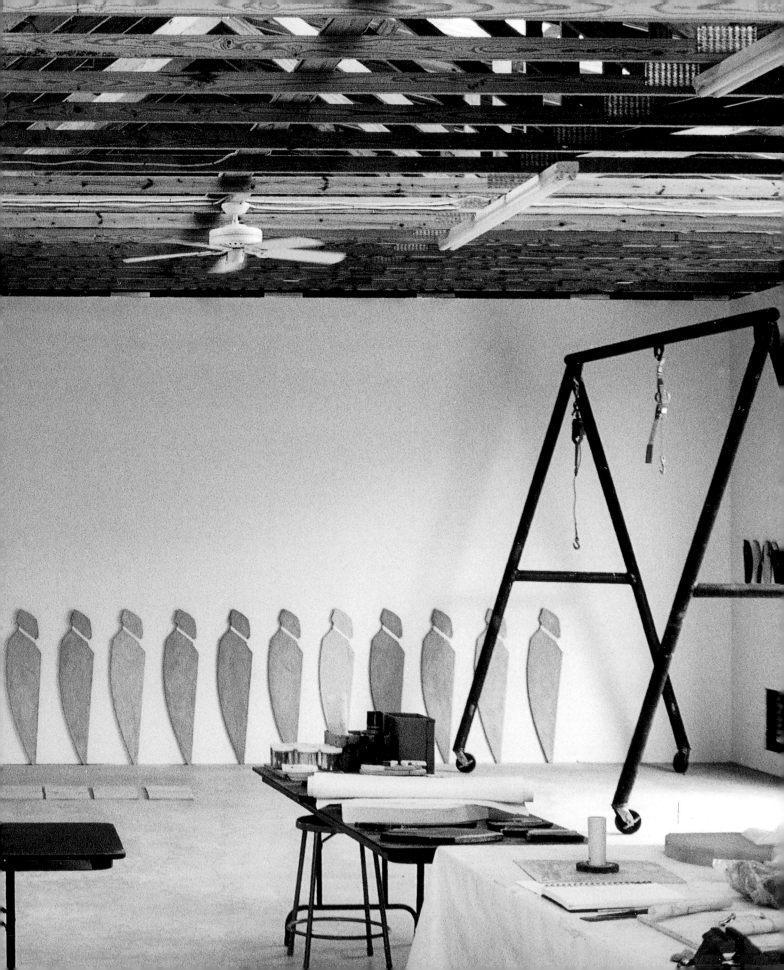